MONMOUTHSHIRE
MURDERS AND
MISDEMEANOURS

MONMOUTHSHIRE
MURDERS AND
MISDEMEANOURS

TIM BUTTERS

AMBERLEY

First published 2022

Amberley Publishing
The Hill, Stroud
Gloucestershire, GL5 4EP

www.amberley-books.com

British Library Cataloguing in Publication Data.
A catalogue record for this book is available from the British Library.

ISBN 978 1 3981 0279 8 (paperback)
ISBN 978 1 3981 0280 4 (ebook)

Typesetting by Hurix Digital, India.
Printed in Great Britain.

CONTENTS

INTRODUCTION

Murder has, is, and, short of a miracle, will always be with us as long as man walks the Earth. Fortunately, for the most part, it is still largely an uncommon occurrence, particularly in Monmouthshire.

The county featured in this book does not share the same geography or borders as the modern Monmouthshire, rather it is the tale of the historic county whose scope and sprawl was considerably larger. Nevertheless, the Monmouthshire of yesterday and today has never been an urban hotbed of crime, particularly regarding murder. Yet killings of all kinds and murderers of all persuasion and motive have left their indelible stain on this fair county.

When murders happen close to home, particularly in a small town, and for the most part Monmouthshire has always been a collection of small towns, it's as if some terrible and unfathomable beast has spread its wings and caught all the inhabitants in its unexpected shadow. No one expects a murder close to home. Yet when they occur they darken everyone's door and prey on everyone's mind. At such times our collective subconscious is aware that something alien and unsettling has brushed by the twin pillars of normality and everyday life, and shaken our belief in the strength of their foundations for all time.

Blood on the streets!

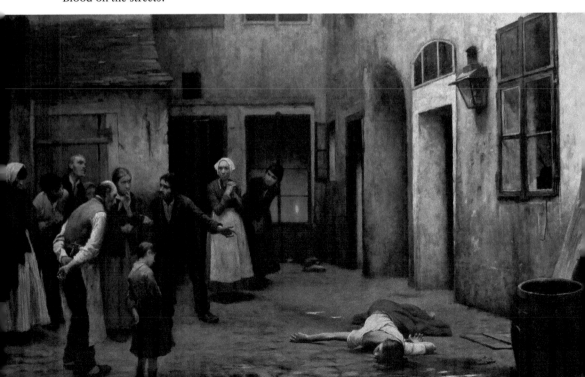

Murder is like the darkness between the stars – it threatens to engulf everything. In the face of such a merciless void, it's vital to hang on to what little light you can.

This book documents and reveals murders and other unsavoury aspects of a different place and time. The raw impact of killings that happened in centuries far removed from our own is often softened by the passing of decades and a collective ennui of the modern mind. We are all at some point guilty of viewing people who lived in ages vastly remote to ours as names in out-of-print books or faces in fading photographs. We often have to step back and remind ourselves that they were once as real and as much a part of the ever-changing now as you or I. The shock we feel at their bloody and horrific ends should not be numbed by the calculated measures of the clock face. Their joy was just as euphoric, their pain was just as vivid, and their hopes burned just as fierce before they met their premature end.

Tragedy will remain just as tragic, murder will remain just as foul, and those responsible will remain just as accountable until the last human being departs this world, and all reckoning and remembering come to an end.

In the meantime here is a small collection of tales from the dark corners of Monmouthshire's past.

1. HELL-BOUND HAROLD: THE BOY WHO KILLED

On being wrongfully acquitted at the Monmouthshire Assizes on 21 June 1921 for the charge of brutally murdering eight-year-old Freda Burnell, fifteen-year-old Harold Jones left the courtroom to an emotional reunion with his tearful parents. Not long after he was escorted to a nearby restaurant for a celebratory meal. In high spirits a jubilant Jones jumped on a dinner table and addressed a large crowd of his supporters with a heartfelt 'I thank you all. I do not hold a grudge against the people of Abertillery for the horrendous ordeal I have been put through.'

Jones was hailed a hero by the other diners who toasted his good health and a memorable victory for justice. Later that day he was whisked back to his hometown of Abertillery on an eye-catching charabanc sporting two large flags, which fluttered free as a bird in the gentle breeze. On his triumphant tour through the western valleys, crowds lined the streets, waving, cheering, and keen to catch a glimpse of the man of the hour. He eventually arrived in Abertillery to a hero's welcome and streets decorated with bunting. He was presented with a gold watch by the great and good of the town, and was carried shoulder-high through the streets where he was born and bred as a brass band played.

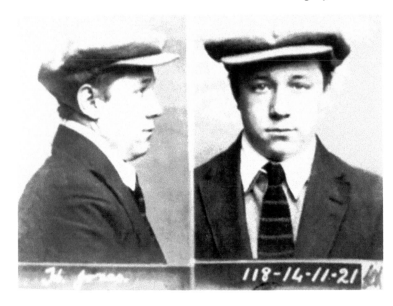

A mugshot of a killer.

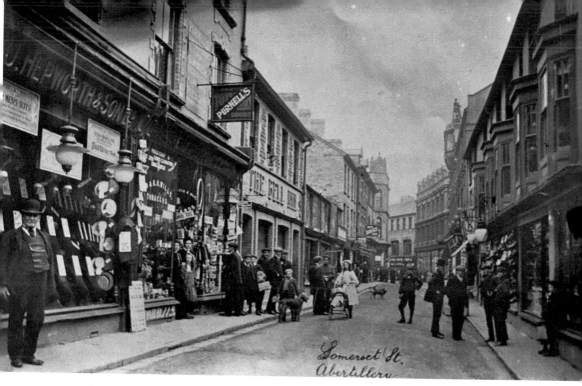

The streets of Abertillery through the murk and mist of time.

The people of Abertillery were euphoric. They never believed that one of their own could commit such a horrendous crime against a girl only three-and-a-half stone in weight, and one who could not possibly have defended herself. For once, the downtrodden members of this strong community thought the scales of justice had tipped in their favour.

One of the first to congratulate Harold Jones on his return was Mr Arthur George Little with the words 'Well done Harold, we knew you didn't do it'.

A mere seventeen days later, Little's eleven-year-old daughter Florence had her throat savagely cut by Jones, who bled her dry over the kitchen sink and then hid the body in his parent's attic.

When the police found Florence the coroner said there were barely two teaspoons of blood left in her body. Not long after her child's murder, Florence's mother called at Jones's house to enquire about her daughter's whereabouts, and although the young psychopath had just finished concealing the body, he still had the gall to ask her how her little boy, who had recently been poorly, was doing.

In the same manner he'd acted after Freda had disappeared, Jones even proceeded to help with the search – similar to the way Ian Huntley behaved after the Soham murders.

Jones committed his first murder, and one he very nearly got away with, on 5 February 1921, when Freda Burnell was sent on an errand to a local birdseed shop where Jones worked. Although the shop was only a few minutes away, the girl never made it home. Jones had tricked her into accompanying him to a nearby storage shed, before sexually assaulting and then murdering her. The body

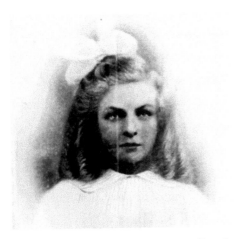 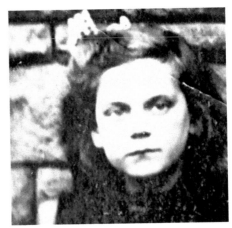

Florence Little (left) and Freda Burnell (right).

was dumped in a secluded lane and was found by a collier at about 7.30 p.m. the next morning. After Scotland Yard officers were dispatched from London to assist local police, Jones eventually fell under suspicion following the damming discovery of Freda's handkerchief in the shed to which Jones had the only key.

Jones's guilt was further compounded by a witness who claimed to have heard screams coming from the shed and the discovery of an axe, which may have been used in the attack.

Jones was subsequently arrested and sent to trial at the Monmouth Assizes where he pleaded innocent and refuted all claims against him, and despite the weight of circumstantial evidence tightening the noose around his neck, he was found not guilty.

After being released to kill again, Jones was finally arrested after the police carried out house to house searches looking for evidence that would lead them to the killer. This time he was caught red-handed with the corpse of a child in his attic, and had no option but to plead guilty. Jones escaped the hangman's justice by virtue of his age and was sent to Usk Prison where he chillingly confessed to the chaplain that he was responsible for the first murder and that the voices in his head had compelled him to carry out the act.

In newspaper reports from the time, Jones bragged about the first murder and revealed: 'I had only read of Scotland Yard men before, now I'd seen them in the flesh and beat them.' Before adding, 'I watched Freda's funeral. I played billiards, ate, and slept as usual.' Describing why he killed, Jones said, 'Quickly as the lightning flashes, the demon had me in his power again. Again there was that blinding light and that dash of fire across my eyes and brain. Once more came the command to "kill!" – and I did.'

The crimes of Harold Jones hit the headlines across the world. The *New York Times* described it as a 'charge of murder perhaps unprecedented in the history of crime'. By its very nature, the case of Jones lays waste in part to nostalgic

Left: The scene of the crime.

Right: An alleyway stalked by a monster.

claims about the innocence of the 'good old days' and mocks the notion that children who kill in the modern era only do so because they have been corrupted and turned into unthinking machines by violent films, computer games, and a materialistic and selfish society lacking in moral fibre.

Unfortunately, humanity's need, however morbid, to understand the monsters that have walked among us through the murk and mist of time will be left unfortunately no more enlightened by the tragic episode that shrouded Abertillery in an impenetrable veil of mourning in 1921. What accounts of the crime do reveal about the personality of Harold Jones is disturbing and riddled with suggestions.

In an almost textbook description of the psychopathic personality, the *World's Pictorial News* wrote soon after Jones' imprisonment at Usk Gaol:

> He can banish what to others would be of the greatest concern like flicking dust from a sleeve. He permitted nothing to worry him and was a fatalist of the most pronounced order. His mind carried him into years beyond his age. His heavy lower face always hinted at lust being pronounced. The general contour of his features suggested the animal being strongly represented. His physique was in keeping with the animal suggestion. He was as strong as a lion and could toy with a sack of potatoes as though it was a matter of mere ounces.

If he were not allowing himself to become intoxicated on the strains from the organ, he was reading all manner of detective stories from the sound and literary ones to the dangerous and trashy cheap ones. It was his close study of these that enabled him to put up so good a fight against Scotland Yard to secure an acquittal on the first occasion.

His cunning and calm though is perhaps better shown in the second case when the mother of the murdered girl called at Jones' house to ask if the girl was there. Harold Jones had just placed the bleeding body of his victim in the attic, and calmly told her mother she had been but had gone out with his sister; and then as an afterthought, he asked how the woman's little boy who had been unwell, was doing. His hands were literally still dripping with the young blood of this very woman's little girl.

He could lie with wonderful ease and conviction. When his back was to the wall he would fight like a badger. I can see him now before Mr. Vachell, K.C., for the Crown, in the first case, lying so cleverly that even this master of rapier-like exchanges of words could not break down his guard to get in a winning thrust.

I can see those eyes lighting up with terrible fires, the scowl of wickedness be-clouding the animal, though pinky face, as he senses the potency of counsel's speech against him. It was the power of their truthfulness that caused the headstrong Jones, who was as vain as a peacock, to show his teeth and snarl from the dock.

Interestingly enough, in their efforts to explain the malignant enigma that was Jones, reporters working for Manchester's *Thompsons Weekly News* revealed how eminent British scientists were searching for the microbe in the brain of Harold Jones, in the hope that this boy of fifteen would have the key to the problem that has worried the world for centuries, namely 'the desire to kill'.

The view of the experts was that the first treatment to destroy the microbe was work and fresh air.

Harold standing in front of Mortimer's Seeds.

Medical men of the time explained that because Jones was immensely big for his years, the work of a shop boy was more of a luxury life than anything else, with the result that instead of the muscles becoming stronger, the brain was allowed to develop and in the absence of any guiding principles, unfortunately in the wrong direction.

These so-called experts pronounced there was a great deal of similar decadency all over the country, and claimed that those who put it down to the First World War were entirely wrong.

Needless to say, no amount of quacks could diagnose and treat the cold and calculating condition of Jones, who sometime after his imprisonment conducted a one-off interview with the *Sunday Chronicle* from his prison cell in a bid 'to put himself right before God', and 'unburden his mind'.

In the interview, Jones explains in the arrogant manner of someone seemingly without repentance and without any desire to make peace with God: 'The great secret of my success I believed was to say nothing and confound by my actions anyone who could say they had seen me near the victims and the murder sites.'

However, when Jones was transferred from Usk, a journalist noticed that the former cocky, arrogant Jones now looked gaunt and fugitive.

While serving time at Maidstone Prison in Kent a medical report on Jones concluded that he was still without remorse for his crimes and that both his murders were due to sadism. The report also hints that certain aspects of Jones' behavior such as his unexplained fetishism for handkerchief collecting, and evidence that at the time of the murders of Freda and Florence, their killer was having full and perverted sexual relations with a thirteen-year-old called Lena Mortimer, whom he once begged to spit in his mouth, all pointed to an association of early sexual development.

Finally released from London's Wandsworth Jail in December 1941, Jones vanished off the radar for a while due to the chaos that was wartime Britain. He later resurfaced in 1947 and was reported as living in London, where he continued to register himself at various addresses under a number of false names. Without any regard to the families of his victims, Jones would often return home to his parents in house Rhiw Parc Road, and local tales abound that the sound of him playing the organ in their front room would haunt the terraced streets, all of which would remain empty as mothers kept their children safely indoors until Jones had departed.

Research shows that Jones married, and had a child, but it is not known if they knew anything of his terrible past. What is known, however, is that as a final gesture of defiance and arrogance, when he died of cancer in 1971 and was buried in West London's Hammersmith cemetery, he insisted on being buried under the name of Harold Jones, the first time he had used that title for twenty-four years.

Neil Milkins, who wrote a superbly detailed account of the case of Harold Jones entitled 'Every Mother's Nightmare,' points out, 'In the aftermath of his crimes, Jones was concerned enough about his safety to hide his true identity but

6008. THE PARK ABERTILLERY

A close-knit valley town that the hand of Harold rocked to the core.

was unconcerned about any retribution that may come upon his family after his death for his past crimes.'

In the end, Jones died as he lived, a cold-blooded psychopath.

WAS HAROLD JONES ALSO JACK THE STRIPPER?

During his extensive research for his book on Harold Jones, Milkins also began to have serious suspicions that the notorious Abertillery child killer Harold Jones could also be responsible for the unsolved 'Jack the Stripper' slayings that devastated London in the swinging sixties?

Jack the Stripper was the nickname given to an unknown serial killer responsible for the murder of six, possibly eight prostitutes in London between 1964 and 1965. The killer's modus operandi was similar to Jack the Ripper. This twisted predator would target lone and vulnerable prostitutes before strangling them to death. He would then strip them naked and knock their teeth out for souvenirs. The sadist sent his last victim to the grave over half a decade ago, and despite a massive police hunt at the time, the killer known as Jack the Stripper was never found.

So strong were Milkins' suspicions that Jones was the Stripper Killer he wrote a book (*Who Was Jack The Stripper?*) that reinvestigates the unsolved and brutally savage Hammersmith Nudes Murders, which left a nation horrified and reeling in disbelief. In the book, Milkins traces Harold Jones movements, who at the time

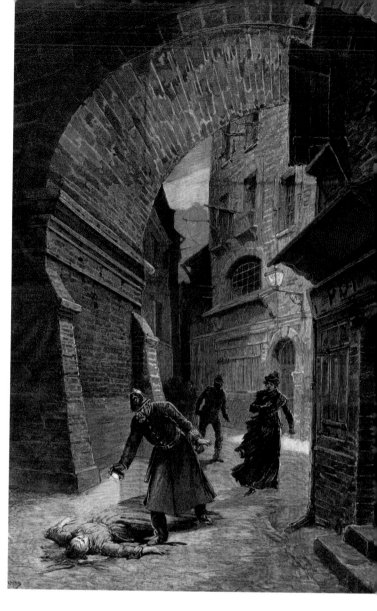

Was Harold also a
modern-day Jack
the Ripper?

of the murders was living under the assumed name of 'Harry Stevens' and 'Harry Jones' and discovered that Jones was living and working in the area when the poor girls were slaughtered.

Somewhat chillingly, Milkins also points out that the last of 'Jack the Stripper's' victims, Bridget O'Hara, was killed on 11 January 1965 – Harold Jones's 58th birthday.

Over the years the names of several persons have been accused of the murders, the most sensational being that of boxer 'Fearless' Freddie Mills, crowned light-heavyweight champion of the world in 1948. Mills, a darling of the media and a hero to millions, was found in July 1965, six months after the last of the murders, slumped in the back of a car in Soho after suffering a gunshot wound to his head. He later died in Middlesex Hospital.

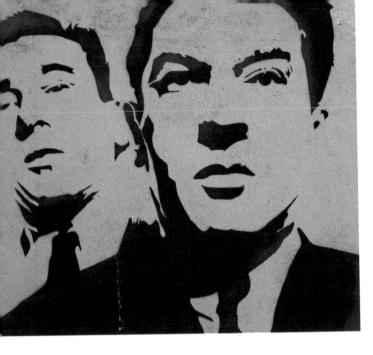

Ronnie and Reggie.

His family and many of his closest friends, including the Kray twins, believed Mills had been murdered. Bruce Forsyth and Henry Cooper were bearers at his funeral, as was boxing promoter Jack Solomons. The detective responsible for bringing the Kray twins to justice, Leonard 'Nipper' Read, headed the police inquiry into the death of Mills and ruled his demise as suicide.

Similar to the Jack the Ripper slayings of the nineteenth century, Jack the Stripper's reign of terror ended in 1965 without the killer being caught. In the same period, a security guard called Mungo Ireland, who lived in the area of the murders, gassed himself to death in a car. Ireland left a suicide note that read: 'I cannot stand the strain anymore.' Police viewed it as a possible confession on Ireland's behalf. Interestingly, Ireland lived only two streets away from Harold Jones.

Mr Milkins explained:

It is not my intention to claim that Harold Jones was responsible for any or all of the murders in London. However, the facts are though, that Jones was not released from prison after he had killed two young girls because he was repentant. In fact, throughout his prison life, he was found to be callous and was seen as a 'no-hoper.'

The only reason he was released from prison was because of the Second World War, and because the prison authorities hoped that it would give Jones his chance in life. After his release, Jones would often walk around Abertillery on his 'home visits' as though he were a star and had something to be proud of.

Records show that he was certainly proud of the fact that he had beaten Scotland Yard after he had attempted to rape and then kill eight-year-old Freda Burnell.

Milkins added: 'All of the eight London murders were committed within a short distance of the Fulham and Hammersmith areas. Harold Jones, claiming to be Harry Stevens lived in Hestercombe Avenue, Fulham until 1962. He was then registered on the electoral roll as Harry Jones and living at Aldensley Road, Hammersmith.'

Professor of Criminology David Wilson said, 'I think Neil's book sheds new light on the Hammersmith murders. We know that Harold Jones was living in the area of the Jack the Stripper killings, and in my experience, there is no such thing as coincidence when dealing with serial killers.'

Milkins added:

Although none of the London victims were children, it should be noted that in 1948, Jones had progressed from an interest in young girls and had married a 35-year-old-woman.

It sends shivers up my spine to think that this evil psychopath could have killed his last victim on his birthday as one last present to himself. If Jones was responsible for the murders and was able to confide in anyone, he would certainly have bragged concerning the Scotland Yard detectives, 'I beat them again.'

Harold prior to his release from HMP Wandsworth.

2. CARNAGE IN PARADISE: A DEMONIC HOME INVASION

After serving a nine-month term in Usk Gaol for burglary, twenty-one-year-old Joseph Garcia was released to roam the world at large on 16 July 1878. The stereotypical stranger in a strange land, the Spanish seaman could only speak a few words of English, but his subsequent actions spoke volumes in any language.

On the same day, he was given his liberty from prison, Garcia hadn't travelled very far when he made a port of call at Llangibby's Castle Cottage on the road to Usk. With disturbing parallels to our own age, the young Spaniard wasted little time in proving that he had not learned any lessons whilst in prison. At Castle Cottage, Garcia committed much more than just another burglary. For in his foul wake he left inside the blood-splattered walls of that cursed cottage, the badly mutilated bodies of farmworker William Watkins, forty, his wife Elizabeth, forty-four, and their three young children.

The scenes inside the cottage were like hell on earth and indicated that husband and wife had put up a long and hard fight for survival before succumbing to stab wounds, while their children Charlotte (eight), Frederick (five), and Alice (four), were hacked to death as they slept. To cap his bloody handiwork, Garcia set fire to the cottage in three different places before taking his leave.

A young lad named Frank James who worked for Mr William Watkins found the murdered man, in his own words, 'asleep in the garden' and rushed away to tell his mother, who quickly gathered it was something more sinister, judging by the scared expression on the boy's face.

One of the first witnesses upon the scene, Mr. E. George of the White Hart Inn, recalled, quite fittingly considering the demonic and diabolical deeds that had taken place there, the overwhelming smell of sulphur.

An artist's impression of how the tragedy unfolded.

In the police records of his witness statement, Mr George recalled,

> It was about seven o'clock in the morning when the little boy (Frank James) came
> here (White Hart Inn) and said 'Mr. Watkins has been killed. I went up to the place
> at once to see what was the matter. When I got there I found Mrs. Watkins lying
> dead inside the gate and her husband was lying dead about four yards from her.
> Smoke was issuing from the top of the house. We succeeded in opening the door
> leading upstairs to the bedroom, but the stench of what smelt like burning sulphur
> was so powerful that we could not go in, so we went outside and broke some
> slates off the roof. This let the stench out and we then entered the bedroom.

Greeted with the grimmest of scenes, George describes how the children were all
lying dead on their beds with their throats cut and how all three of them had been
badly burnt after being so ruthlessly butchered.

In the house, potatoes were found in a dish, as though the husband and wife
had been eating together and there was a little plate and spoon nearby for the
children's food.

Quite poignantly, it was also discovered that the clock face had also been taken
out of the family's timepiece and the pendulum thrown upon the ground. As if

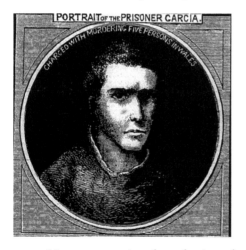

Newspaper cuttings from the time of
the dark deed.

to give the world a chilling reminder that time had stopped completely for the Watkins's household on that day.

A *Chronicle* reporter allowed to later visit the scene by the police wrote,

> A demon-like vengeance had been lavished on every article of furniture. The woman's throat was not only cut, as were also the children's, but she was stabbed in several places, and one of her hands was maimed, apparently with a sharp instrument. The man appeared to have been dealt with in much the same way. Another peculiarity in connection with this dreadful affair is the circumstance that the poor woman's body was covered with wallflowers plucked from the garden, and strewn over the corpse as though in mockery.

Joseph Garcia, who was seen loitering a short distance from the Watkins's house, once in the morning, once in the afternoon, and once in the evening by three independent witnesses before the murder was committed, was arrested at Newport railway station the following day between 12 and 1 p.m. after police had issued a description of the suspect.

A policeman had observed a man matching Garcia's description go to the fountain for a drink. He accosted him and after finding his words were not understood, asked Garcia whether he was a Frenchman, a Spaniard, or an Italian. Getting nothing out of him, he informed a certain Sergeant McGrath, who recognised in Garcia, an old acquaintance, for the desperado had until very recently been imprisoned at Usk Prison for a burglary committed at St Brides.

Garcia was arrested wearing a black cloth coat, round bowler hat, and dark trousers. He also had on a pair of boots the same size and make of the murdered man. His clothes were very wet, and there was blood on his wrist. His left cheek was slightly scarred as though with a sharp instrument.

Something savage this way comes.

With regard to Garcia's appearance, it was said to be not at all alarming. He was described as a slightly built short man, with a long, sharp nose and thin features, that contained small eyes, surmounted by a thick shock of black hair. His manner was recorded as being composed, and he spoke in a decided tone in reply to the questions put to him, displaying not the faintest symptom of emotion of any kind. He denied all charges and when asked how he accounted for the considerable property in his possession. which belonged to the murdered people, he said he found it.

At his committal hearing at Caerleon Magistrates, the crowd in and outside the court was enormous and the *Chronicle* reported,

> The noise outside the court was powerful enough at times to prevent the witness from being heard, and from the character of the exclamations which permeated to the interior of the court the crowd appeared ready to lynch Garcia.
>
> Although the babble of contending voices was at times perfectly deafening, the prisoner preserved a calm demeanour throughout the trial. The only movement visible on his features was the shooting to and fro of his eyes – very dark and very brilliant, which at times betrayed a latent interest in what was going on.

At the Monmouthshire Assizes held in October, it was argued that nobody would probably ever know the motive of the man who committed these murders, but it might just be that the prisoner was refused a night's lodging or some food by the Watkins household, and then committed the crime.

In his summing up the judge urged the jury to remember that Garcia was not seen all the day after the murder, that he was found with the stolen goods, and that he had blood upon him.

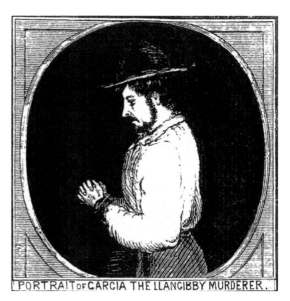

Portrait of the killer as a praying man.

PORTRAIT of GARCIA THE LLANGIBBY MURDERER.

The jury found Garcia guilty, and he was sentenced to death. The condemned man betrayed no reaction on being informed of his sentence.

Garcia apparently did not sleep well during his last night on Earth, and when he rose between six and seven o'clock on Monday 18 November to await the noose at Usk, he failed to eat his breakfast. When the notorious executioner William Marwood, who developed the more merciful 'long drop' technique of hanging, bound Garcia's arms to his sides, the prisoner submitted with the greatest meekness and appeared as if all his physical strength had left him.

Uttering pious exclamations to the end, Garcia was heard to say on three occasions, 'I am innocent, I never did it.'

An *Abergavenny Chronicle* reporter on the scene of the execution wrote:

The poor wretch Garcia presented a ghastly figure as the procession made its way to the repulsive-looking scaffold. From the cell to the scaffold was only a few paces, but, few though they were, they were too many for the wretched culprit. His strength entirely deserted him. The shadow of death had already fallen upon him. He was dressed in his blue sailor's trousers and his blue jersey. His face and neck were colourless. As soon as he saw the scaffold he gave one glance at it and shut his eyes. From this time he was completely overcome. His head swung helplessly from side to side as if his life had already fled. His strength had utterly gone and he was partly supported, partly dragged, up the steps by the warders who were on each side of him.

Hovering as near his person as the presence of the warders would permit, was Father Echevarria, the Spanish priest, whispering short prayers and pious ejaculations in the ear of the doomed man. With Garcia finally stood upon the drop, the last moment had now come. Father Echevarria stepped forward and pressed his little crucifix to the lips of Garcia, who smiled faintly and said in the Spanish tongue, 'My mother! Let the Spanish consul write to my mother.'

Quick as thought, a white linen covering was thrown over Garcia's face. Equally quick was the rope placed around his neck and amidst the prayers and invocations of priests, Garcia was hurried into the presence of the 'Great and Righteous Judge who cannot err'.

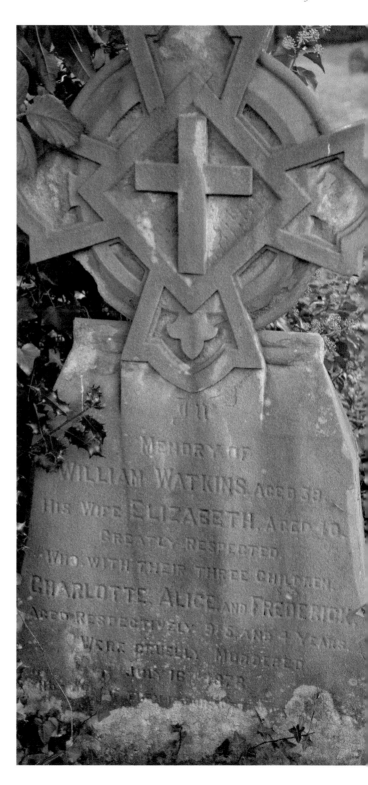

The Watkins family's final
resting place.

3. INSTITUTIONALISED: VILLAINS AND THE VILIFIED

In Victorian times being committed to a 'lunatic asylum' was considered a fate worse than prison. These forsaken outposts of ennui and despair were the last place any mentally unwell person would want to end up if they were to have more than a snowball's chance in hell of getting fighting fit again.

There was more horror than healing to be found behind the imposing doors of these guarded buildings, which became all the rage under the reign of the Widow of Windsor – Queen Victoria. In short, no matter how accommodating their regime, they were prisons disguised as hospitals. Patients were not treated like people who needed help, but more like dangerous wild-eyed beasts who the public needed protecting from, less their lunacy infected the greater good like a particularly potent parasite.

Originally known as the Joint Counties Lunatic Asylum, and later the Monmouthshire Mental Hospital, the sprawling Tudor Gothic-style institution which overlooked and cast a shadow over Abergavenny for well over a century was erected in 1851 and named Pen-y-Fal. Originally intended to house a maximum of 210 patients, the hospital was catering for well over twice that number by 1867 and subsequent extensions to the main hospital entailed that eventually Pen-y-Fal housed a staggering 1,170 inmates and covered 24 acres of ground.

'Madness' by George Bell.

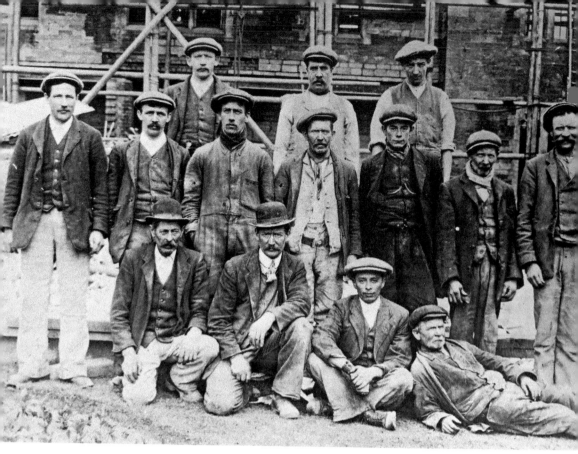

The men who helped build Pen-y-Fal.

In its early days, postnatal depression, alcoholism, senile dementia, or even infidelity, which was then classed as 'moral insanity', were grounds enough to have you committed indefinitely to its grim environs. Many a black sheep or rebellious outsider was condemned to the care of the asylum under the label of being prone to antisocial behaviour or melancholia. All the authorities needed was a doctor's certificate and a relative's signed agreement that you were in desperate need of special measures and away with the men in white coats you would go. In fact, 'gone to Abergavenny' used to be a metaphor in the South Wales valleys for going insane.

Men of wealth often used the asylums to ditch unruly wives and give them a short, sharp shock. They would take advantage of the medical condition known as 'hysteria' to rid themselves of ladies who didn't act as polite and agreeable as the gentleman thought was proper.

Overall, the chances of admission were higher if you were a woman from any social class. Distraught mothers who lost their sons or husbands to war, those classed as leading an 'immoral life,' having 'domestic trouble', having 'menstrual problems,' or prone to 'the menopause' or 'nymphomania' could all be classed as being in dire need of being 'mentally corrected'. Worst of all, women who thought for themselves and wanted to educate themselves further were classed as having

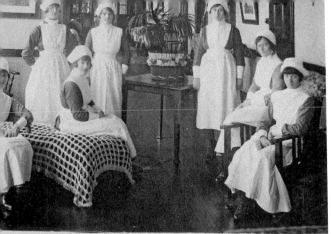

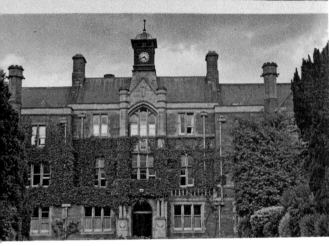

Left: A warm welcome awaits at the Joint Lunatic Counties Society.

Below: The asylums made many a lady nervous.

'overaction of the mind'. In certain asylums 'book reading' was actually listed as a reason for admission.

For curiosity's sake and to poignantly prove how much more enlightened we are as a society in regard to the complexity and maladies of the human condition, here are just a few of the actual reasons, including Pen-y-Fal, cited for admission to various asylums between 1864 and 1889:

> Intemperance and business trouble kicked in the head by a horse, imaginary female trouble, hereditary predisposition, jealousy and religion, laziness, masturbation for 30 years, mental excitement, opium habit, overaction of the mind, over study of religion, overtaxing mental powers, political excitement, religious enthusiasm, asthma, bad company, bad whiskey, dissolute habits, egotism, epileptic fits, time of life, superstition, spinal irritation, grief, feebleness of intellect, gathering in the head and dissipation of nerves.

The list goes on, much like a historic testament to the twin evils of ignorance and prejudice, but to break it down to its bare bones, madhouses were dumping grounds for the poor, unsightly, and down on their luck members of society, including many children with epilepsy and developmental disabilities that the public at large wanted removed from their sight. In the case of many of the

No place to dream – inside the wards of Pen-y-Fal.

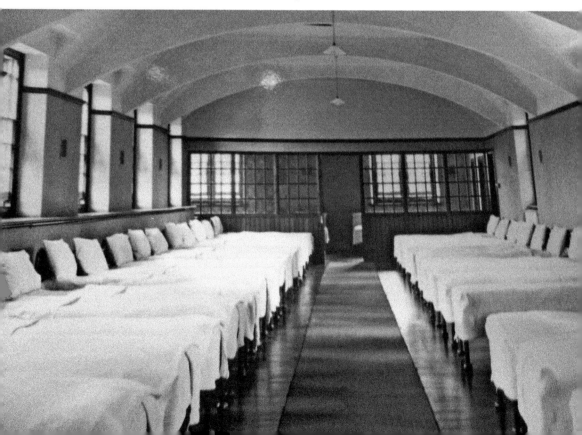

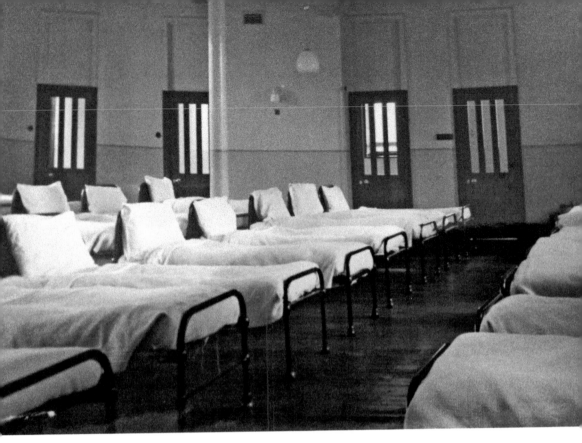

Privacy was low on the agenda at Pen-y-Fal.

inmates, their difference and willingness to walk a different path was the very reason the status quo felt the need to steamroll them into meek submission by any means necessary. And as you can see from the ludicrous reasons for many of the admissions, the means were often foul.

Once you were safely under lock and key there was no official release date. In fact, you couldn't even appeal against your detention. Your best hope would be a kind friend or relative who was in good standing in society would request you be discharged. Until that distant, and for some impossible, dawn, life was a bland, drawn-out affair capable of eroding the soul and paralyzing the mind.

Privacy was not considered essential for a patient's well-being. The pauper wards were filled with as many beds as humanly possible, all lined up in regimented rows with no consideration to personal space. Males and females were strictly segregated and the day revolved around a tedious routine of waking, eating and work. For men, this involved helping out on a nearby farm or hospital bakery, and for women, the hospital laundry. Both genders were expected to pitch in with cleaning duties. For those deemed unfit or unwilling to work, they would be allowed to roam the grounds for an hour every morning or afternoon. Men were often encouraged to participate in gardening or sporting activities but the fairer sex was denied to partake in such demanding pastimes and had to remain content with a leisurely stroll around the grounds instead.

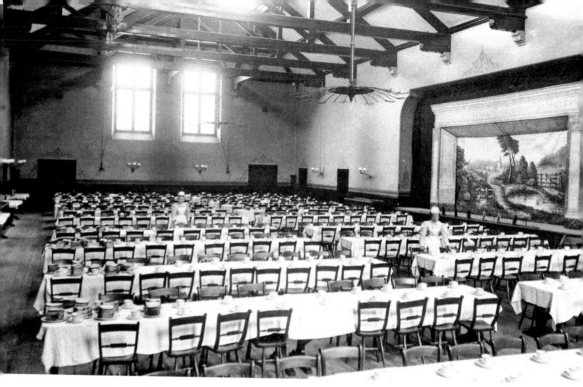

Grub's up! The dining room at Pen-y-Fal.

By far the worst aspect of asylum life was the experiment and barbaric treatments patients were subjected to in the name of progress and endeavor but which in actual fact amounted to torture by another name. In regard to mental health issues, the key words, particularly in Victorian times, were containment, suppression and restraint. If a patient stepped out of line, there were a number of ways to reign them in. Straight jackets and padded cells were a popular way to stop a patient harming themselves and others. Fastening excitable and aggressive patients to their beds was also a routine method to curb the 'craziness'.

Those prone to melancholy received hot baths in a bid to lift their spirits. Such a treatment sounds warm-hearted and progressive but really it was ignorance dressed up as science. The patient had no choice in the matter. They were placed in the tub with water up to their chin. They were then covered with a canvas sheet, with a little hole for their head, and they were then left to stew in their own juices for hours, in some cases days, as cold water was drained from the bottom and a ready supply of warm water was constantly added. Yet such a water treatment seems almost leisurely compared with its cold-water counterpart. If you were deemed in need of 'calming down' by the medical authorities, there was a range of options at their disposal. In some asylums a patient would be forced into a cold shower room, restrained and doused until compliant. In others, an individual would face the humiliation of being tied naked to a chair as bucket after bucket of ice water would be poured over their helpless heads. And here's where it gets particularly medieval. Some asylums adopted a system similar to the ducking systems once used by religious and perverse zealots during the witch

hunts. Patients would be strapped to a chair and repeatedly dipped into small ponds until they were on the brink of passing out.

They were then given a few minutes to regain their senses before the whole process began anew and the patient was satisfactorily broken.

Water treatments could carry on for days and would only end when an asylum physician had deemed that the individual's state of mind had been put at ease and behaviour modified.

The art of spinning was a particularly torturous treatment. Patients were strapped to a large wheel and spun at high speeds. With the exception of making them puke profusely, it's not certain what desired effect a spin on the wheel was supposed to invoke. Even more sinister and barbaric was the branding iron. Like it said on the tin, hot irons were pressed against a patient's naked flesh in an attempt to 'bring them to their senses'.

Using drugs to treat asylum patients wasn't widespread in Victorian times but towards the end of the nineteenth century, a chemical cosh called paraldehyde became all the rage. The sedative had a range of uses from inducing sleep to calming convulsions and nullifying fits of rage. Patients would often have their evening tea spiked with this reliable downer.

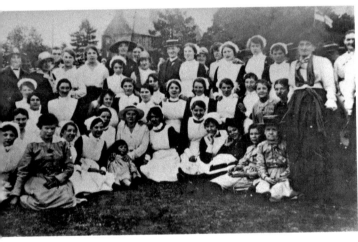

Pen-y-Fal's staff and residents put a brave face on things.

As the twentieth century dawned, the older and more primitive 'treatments' were discarded in light of what was considered more progressive treatments such as lobotomies and ECT (electroconvulsive therapy). One psychiatrist described lobotomy as 'putting in a brain needle and stirring the works'. Working with the sort of ice picks and restraints that wouldn't look out of place in a medieval dungeon, early practitioners of this perverse practice appeared to believe they were like scientific exorcists, drilling holes into skulls to release evil spirits. In reality, they were gleeful butcherers who were working blind to mangle and maul that most intricate, delicate, and wonderous thing – the human brain.

By forcing an 8-cm steel spike attached to a wooden handle through a hole drilled in the skull, surgeons would literally stab and slash at the brain to sever any connection the frontal lobes had to the rest of the brain. The results were hailed as a miracle cure and a magical fix. The men in white coats declared that with inpatients where there was once rage, there was now calm; where once there was turmoil there was tranquility; where there were once the demons of delirium and disturbance there were now angels of acceptance and acquiescence. Such was the fervor to promote this revolutionary treatment that at its peak the UK was conducting 1,000 lobotomies a year. In 1949 Egas Moniz was awarded the Nobel Prize for introducing lobotomy to the world. Yet by the mid-1950s the procedure had fallen from grace. The mute indifference, robotic automation, and gross retardation of many who had survived the intrusive workings of the lobotomy spike haunted those who once believed that hacking away at the brain could offer up any sort of redemptive epiphany. It did not. All it did was lead to the terrible ruination of human beings.

Take the case of John F. Kennedy's sister, Rosemary. In 1941 she was involuntarily committed to an asylum by her father for mood swings and what was classed as 'challenging behavior'. At his request and without her consent she was subjected to a lobotomy. The aftermath was horrific. Rosemary couldn't walk or talk and suffered from permanent incontinence. Her intellectual capacities were that of a two-year-old child. She had been failed by both science and society.

Yet the tide was turning and and the darkness slowly began to recede as a new approach and understanding took hold. Antidepressants and antipsychotics coupled with a determination to understand, help and shine a light on that which had been previously condemned and left to rot in the shadows. From the 1980s onwards the haunting and historic asylums began to shut up shop and in an ironic twist of fate, care was given in a community that had previously exiled anything different or difficult.

Pen-y-Fal finally closed its doors for the last time on 17 August 1996, and a large part of the original building still stands as part of a sprawling housing development, which is riddled with an abundance of clues and pointers as to the former legacy of the site. Not least the innocuous and pleasant grassy verge where today children play and dogs walk, beneath which 3,000 poor souls are buried in unmarked graves. Their personal tales may be forgotten but the story of their lives remains a valuable lesson to us all.

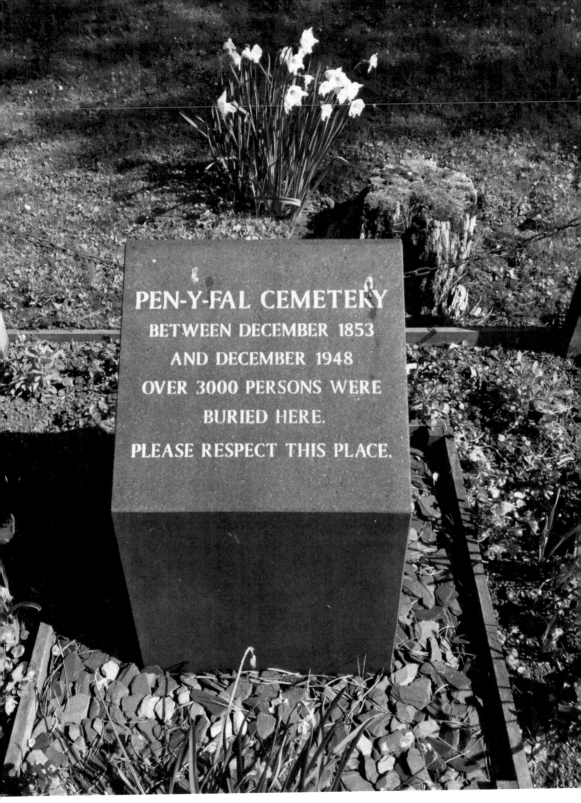

A grave disorder.

4. VICTORIAN AND VICIOUS: THE SLAYING OF BLOODY MARY

It was another busy Friday night in Victorian Abergavenny; the date was 16 September 1892, and the public houses were heaving with the trade of customers eager for the high spirits and blessed oblivion to be found in a pint of beer or a shot of whiskey. Yet for one reveller, this bawdy night of drunken abandon was to be her last.

Mary Conolly, a well-known alcoholic and prostitute, was celebrating her release from Usk Gaol after having spent the last twenty-eight days there for being drunk and disorderly.

Mary was renowned throughout town as a 'slave to the bottle' and during the day she had stumbled from one public house to the other, busily slating the thirst of the demon on her shoulder whilst toasting her newly acquired liberty.

In her rounds of long-forgotten Abergavenny pubs as the Foresters Arms and the Cross Keys Inn, she was accompanied by a strange man not familiar to the beady and enquiring eyes of the local inhabitants.

Her final port of call and last shot of liquor before she was ripped bloodied and screaming from this mortal coil was in the snug confines of the town's Somerset Arms.

At 7.30 p.m. that evening Mary and her companion entered the pub where she ordered a whiskey for herself and a beer for the mysterious man. Less than an hour later Mary's throat was cut from ear to ear with such animalistic savagery that her head was almost decapitated.

A stately affair – one of Abergavenny's oldest pubs.

The Forester's
Arms once stood in
Tudor Street.

The Hen & Chickens
pub in Flannel Street.

Covered in blood and in what must have been unbearable agony, she dragged herself 200 yards from the spot where her attacker had left her for dead, in a desperate bid for help before the life seeped out of her completely.

Unfortunately, her wounds were far too severe and Mary, lying prostrate and pale in a pool of her own blood, was found in the gutter only a short time later by railwayman Edward Wilkins.

The poor doomed daughter of Jeremiah Conolly and resident of Pant Lane would never again bear witness to the rising of a sun or the falling of a star. Her eyes were unseeing, her heart had been stilled and her final horrors had been rendered mute for all time.

She was tragically dead, butchered by the murderous whim of a madman's hand at the age of twenty-two.

An *Abergavenny Chronicle* report from 23 September 1892 states:

The scene of the murder was on one of the allotments abutting upon the newly made Hatherleigh Road and leading from Brecon Road near Hatherleigh Lodge

to the Union Lane a few yards below the workhouse garden. A guard employed by the railway company was proceeding to work along Hatherleigh Road when his attention was attracted by smothered choking sounds and having struck a match he looked around and discovered what he first thought to be a heap of clothes in the gutter. On closer examination he found it to be a woman with her face covered in blood and her dress saturated in blood, which had flowed from a deep gash in her throat.

Wilkins ran off to inform the police immediately and word soon spread like wildfire through what was then known as the 'Irish part' of the town where Mary had lived.

The 'Irish part of town' – Abergavenny before the slum clearance.

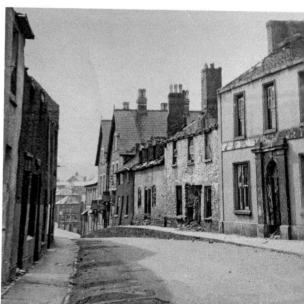

The 'Irish part' of town, so-called because of the number of Irish immigrants residing there, once encompassed the whole of the Tudor and Castle Street areas with its characteristic sprawl of medieval and Elizabethan dwellings, narrow, winding streets, numerous pubs, and well-known brothels. This was of course prior to the 'slum clearance' schemes of the 1950s and 1960s, which many felt ripped a lot of the heart and soul out of 'old mother Abergavenny'.

The murder scene was visited by the county police surgeon Dr Elmes Steele before Mary's corpse was removed to the workhouse mortuary, where Steele ascertained the cause of death as a massive wound that had severed the windpipe.

Superintendent Freeman, who also attended the scene of death, said at the inquest, 'I saw her (Mary) in the position in which she was found. She was on her back, face upwards, she was in the gutter lengthwise, her head towards Brecon Road and her feet toward the Union.'

The *Chronicle* reported, 'A minute description of the man who was seen in the girl's company was given and great anxiety was manifested throughout the town that the culprit should not escape.'

The town needn't have worried because to everyone's shock, a little over a day later, a thirty-year-man living in Lower Hill Street, Blaenavon, who went by the name of Thomas Edwards, walked into the police station in the early hours of Sunday morning and confessed to Mary's murder.

Baker Street, once the home of Abergavenny's police station.

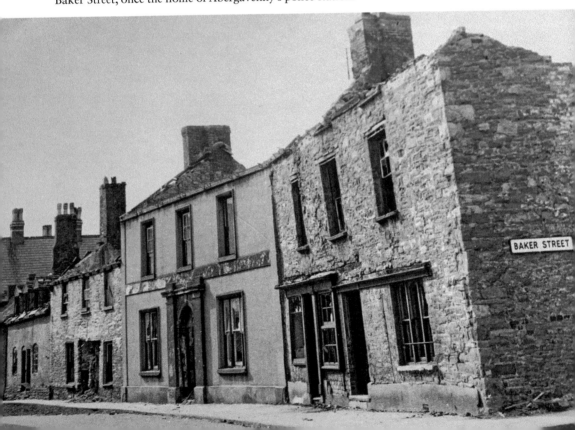

Abergavenny as it would have looked in Mary's time.

Edwards, a former soldier who had previously served in the 53rd Shropshire Regiment, was said to exhibit little concern regarding his position and showed no remorse or regret. He was described as a man of slight build with a somewhat vacant expression.

In a voice devoid of all emotion Edwards told the court during his one-day trial: 'She (Mary) asked me to go along with her and she took me into some garden or field. She laid down and I cut her throat with a razor. I knew her about two months ago and she took my two-pound off me and she had also given me the "bad disorder".'

Quite shockingly a cold-blooded Edwards went on to reveal, 'I left her on the ground and came back to the same public house (Somerset Arms) at which I had a glass of beer.'

Edwards's Blaenavon landlady Mrs Morgan later explained to a reporter from the *Western Mail* that Edwards would often go to Abergavenny by train, for the purpose, so he made out, of seeing a sister. On one occasion he stayed four or five days and when he returned was without any money. Suggesting that Edwards had more of a relationship with Mary, or at least other women of 'ill repute', than he later cared to admit.

Edwards's defence pleaded that the accused was of not sound mind and that his mother had been confined to Abergavenny's Pen-y-Fal Asylum for the last twenty years. It was further revealed that his uncle was known as a complete imbecile and his grandfather went by the name of 'silly Davis'.

In his only explanation of why he took such a young life and cruelly cut it short, Edwards said:

> I think it is about six or seven years since Colonel Findall commanding the Shropshire Regiment was murdered in Birmingham by one of these loose girls. Since then my mind has always been against them.
>
> If I had a good chance I should have killed one before and intended going to Newport and killing one or two there, only I had no money.
>
> I served in the Egyptian campaign and got invalided from there with a very bad fever and suffered from pains in my head and I had suffered from the pains before committing the deed.

The jury didn't hesitate in passing a verdict of guilty and in passing sentence the judge told Edwards: 'I can only pray you take earnest advantage of the time you have yet to spare here. Short as it may be, it is abundantly sufficient to prepare yourself for the meeting of your God.'

Said to be apparently unconcerned to his impending fate, by all those who visited him in Usk Prison, Edwards kept his appointment with the hangman's noose on 27 December 1892, at 8 a.m.

Minutes later a black flag wIth the word 'JUSTICE' emblazoned upon it in bold white capitals was hoisted high above the prison walls. The assembled

crowd greeted the sight of the flag with cheers as it flew fiercely indifferent and eternally elusive in the grey early morning skies.

Yet for poor Mary, even death could not free her from further indignity. As a Roman Catholic, the church to which she belonged deemed her as a 'notorious public sinner' and refused her the usual Catholic rights of burial on the grounds that she had not been reconciled with her maker before death. As such there was no burial service for Mary, who was finally laid to rest in an unmarked common grave, as a handful of her relatives and friends offered up silent prayers to a distant and authoritarian God in the hope of some sort of salvation for the girl they had once known and loved.

Mary's final resting place?

5. SOMETHING WICKED THIS WAY WANDERS: A TRAMP'S REIGN OF TERROR

When the lazy autumn sun crawled sluggishly into the heavens on another routine October day in 1921, David and Margaret Thomas were busy with the early morning mundane chores common to couples throughout the land.

Little did either of them suspect that one of them would not live to see another sunrise and the other would have their acute sense of loss compounded tenfold by being forced to confront the terrible vision of their beloved lying lifeless and limp after being battered senseless in an inexplicable act of brutality.

The hearty country breakfast of bacon and fried potatoes would be the last meal that Mr and Mrs Thomas would share as husband and wife in the brief eighteen months of married harmony they spent living in Lapstone Cottage on the Llanover Estate.

Mere minutes after David kissed her goodbye and left for work at Ffawydden Quarry on that fateful morning, Margaret Thomas's blood would run cold and her heart would beat no more.

Lady Llanover and Benjamin Hall who owned Llanover Estate.

Something wicked this way comes.

The foty-eight-year-old woman would be sent to the cold and dark of an early grave by an opportunistic tramp – a wandering chancer who had been observing the Thomas household with a grimly calculating eye, waiting for his chance to pounce and commit what the *Abergavenny Chronicle* of the time called 'a most dastardly outrage'.

The tragedy unfolded when Margaret's unsuspecting husband returned to his 'fairy-tale cottage' that evening to find the house shrouded in darkness and the front door bolted. To add to his growing uneasiness, David noticed that the couple's pigs had not been fed or released from the sty and the chickens were still in their coop. His anxiety threatened to spill over into panic when he also noticed that one of the upstairs windows was mysteriously open.

Grabbing a ladder, David climbed into the window and rushed into the engulfing gloom of the house only to find the bedroom had been ransacked. With nerves taut with foreboding and a mouth as dry as a funeral drum, David Immediately headed downstairs only to be confronted with the horror of horrors.

His wife of a year and a half was lying in a pool of congealed blood. Her body had been casually discarded amongst the general chaos of a looted kitchen whose contents had been littered in such a haphazard manner it now resembled more of a war zone than a haven of domestic bliss.

Poor Margaret's head and face also showed the all too visible signs of the savage beating it had endured at the hands of an apocalyptic rage, and an 18-inch blood-encrusted iron bar laid stark and complicit next to the murdered woman's body.

The sight of the murder weapon was all too much for the husband's heart to bear. Devoured by grief and with a mind stripped clean by sorrow, he ran screaming from a home whose happy memories had been obliterated by an unfathomable madness from the abyss.

In the wake of this terrible discovery, the neighbours were alerted, the police were informed, and a major manhunt was afoot. It was declared to be of the utmost importance that the perpetrator of such a dastardly deed was caught forthwith.

A murder of crows.

When he came to his senses a day later, David told the *Chronicle*:

My wife and I were a most happy couple and she was very cheerful when I left for work that morning. When I returned in the evening I noticed that the blinds were drawn downstairs and the front door was locked. A strange feeling came over me, I thought that something must have happened to my wife. When I eventually entered the kitchen I saw the ghastly sight of my beloved lying on her face and there was blood all over everything. There was a heavy bolt near her body with a nut riveted at the end. It was the sort of thing they use on the railway.

The heartbroken husband was then reported to have broken down in tears, before wiping his eyes and saying, 'You don't mind me crying, do you? I can't help it. All last night I could hear her crying to me, "Dai, Dai!" But I knew she would never speak again. The poor little thing had no chance to cry out. She had hardly finished her breakfast. The things were still on the table and there was still some tea in the cup. She was a little woman and what could she do against a man?'

Although amongst other things, a blue suit and a pair of boots had been stolen from the house, the police at the time seemed to concur that the murder was probably not premeditated and was due to some outburst of 'elemental passion'. Near the scene of the murder was found a 'tea jack', which was described as the kind usually used by the 'tramping fraternity'. This, coupled with the fact of

numerous reports of a strange man loitering in the vicinity of Lapstone Cottage in the two weeks before the murder, seemed to point the finger of blame quite firmly at a 'gentleman of the road'.

In the days after the murder, rumours circulated about a vagrant seen in the area 'foaming at the mouth', but this was dismissed as 'fantastic' by the police, who eventually succumbed to public pressure and arrested a sixty-two-year-old tramp by the name of James Coghlin.

Coghlin was released from custody a few days later without charge, to cries of despondency amongst the public and media who formed a general consensus that the Lapstone cottage murder would probably be added to the long list of unsolved crimes.

By the time of Margaret's funeral four days later on 30 October, her killer was still at large and her death still unavenged. Her funeral was said to attract 'remarkable scenes', with people coming from far and wide to pay tribute. The lane that runs past Lapstone cottage was reported to be packed from one end to the other with over 3,000 people. The funeral was held in Goytre's Saron Baptist Church and was attended by the owners of Llanover Estate – Lord and Lady Treowen.

At the service, the minister said of the murderer: 'If this man whoever he was, shall escape the judgment of our law, there is a judgment which he shall never escape.'

Nineteen days later on Friday 18 November, a forty-two-year-old man was arrested on the mountainside above Cwmbran. His name was William Sullivan and he was described as a 'native of Cwmbran, but of vagrant habits'. At his appearance at Pontypool Magistrates, he was described by the *Chronicle* as, 'A very thick-set man, a few inches over five feet in height with strongly marked features and almost white hair.' It was reported that as the prisoner left the dock he was said to glance at the ground and smile. Although Sullivan pleaded not guilty from the point of arrest to his eventual sentencing. the evidence against him was quite damning.

It later transpired during his trial at the Monmouthshire Assizes, on 8 February 1922, that Sullivan was seen by a succession of witnesses in the location of Lapstone Cottage a short time prior to the murder of Margaret Thomas. The prosecution also proved that Sullivan had attempted to sell the suit of clothes and boots formerly belonging to David Thomas, which were taken from the cottage on the day of the murder.

The most incriminating testimony, however, came from Sullivan's brother and brother-in-law, who told the court how they had met Sullivan on the afternoon of the murder in Cwmbran's Forge Hammer Inn, where the accused bought them three pints of beer each.

A *Chronicle* reporter wrote at the time: 'It is a very peculiar thing that a man of the tramping class who travelled from workhouse to workhouse should appear at the Forgehammer in Cwmbran and treat his relatives to drink in such a lordly manner.'

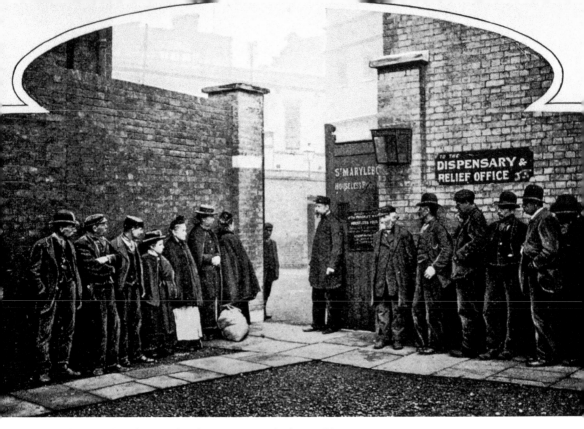

The ragged and the restless lining up outside the workhouse.

When questioned, Sullivan remained vague and claimed he had earned the money in the employment of a woman he could neither remember the name nor address of. During the trial, it also came to light that Sullivan had served in the army since 1901 and was honourably discharged in 1909. Since then he had not had regular employment and journeyed from one workhouse to another.

On 9 February the jury retired for two and a half hours before returning with a verdict of 'Guilty of the wilful murder of Margaret Thomas'. Mr Justice Darling passed the death sentence as a pale and haggard-looking Sullivan was marched away. Condemned to the cold care of the angel of death, a terrified Sullivan exclaimed loudly in desperation, 'I am not guilty, and have always said so!' Sullivan's appeals were created with a stony silence by all in the packed courtroom as they fell futile and forsaken from his lips.

On 22 March, the renowned executioner John Ellis, who would cut his own throat with a razor ten years later, arrived at Usk Prison. The very next morning Sullivan was given the rare distinction of becoming the last ever person to be lynched in Monmouthshire.

The condemned man's body fell through the trapdoor and his spirit into the gaping jaws of hell at exactly 8 a.m. Justice was declared done and the gathered crowd dispersed.

Right: The hangman John Ellis.

Below: Ashes to ashes and dust to dust.

6. TALES FROM THE HANGMAN'S NOOSE: THE FORSAKEN AND THE DAMNED

When James Gibbs was brought before the Monmouth Assizes to stand trial for murdering his wife Ann, he knew his prospects were bleak. The jury was told how Gibbs, renowned as something of a ladies' man, had viciously slashed his wife's throat and discarded her bloodied corpse in a country ditch, just so he could be with his fancy woman.

When police discovered Ann's rotting remains three weeks later, there was not much left of the woman who Gibbs had been married to for under a year. Amidst the terrible stench of decay and writhing maggots, which covered her rotting flesh, the police noticed something that literally glittered with the promise of revealing the identity of the killer – a gold watch.

The timepiece was engraved Ann Gibbs and the boys in blue thought it strange how the murderer would have left behind such a revealing and valuable trinket. They took the unusual decision to leave the body where it lay and stake out the murder site in the hope that the guilty party would return. Their gamble paid off. In the dead of night the person they were looking for returned. They had caught James Gibbs red-handed.

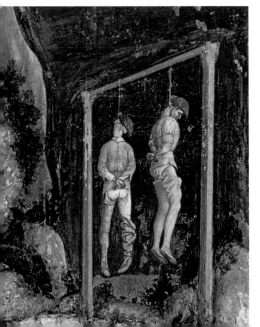

Studies of hanged men by Pisanello.

Mr Justice Lush agreed it was an open and shut case. He also agreed that an eye warranted an eye. Donning the black cap and gloves of the hanging judge he looked an ashen-faced and trembling Gibbs square in the eye and said the words that have stilled the blackest of hearts.

> The sentence of this court is that you will be taken from here to the place from whence you came and there be kept in close confinement until August 24, 1874, and upon that day that you be taken to the place of execution and there be hanged by your neck until you are dead. And may God have mercy upon your soul.

Gibb's death sentence was historic because he was condemned to be hanged at Monmouthshire's major prison, Usk. Prior to that point, Usk had never been a hanging prison and it was a change that did not sit well with the population both within and outside those unforgiving walls.

Since Anglo-Saxon times until its abolition in 1964, hanging was Britain's chief form of execution. Between 1735 and 1964 England and Wales bore witness to 10,935 civilian executions. On 26 May 1868, Fenian Michael Barrett was the last man to be lynched in public in the UK. Two days later a law was passed that capital punishment was now to be only carried out behind prison walls.

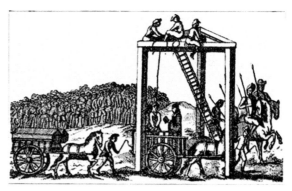

Hanging is as old as the hills.

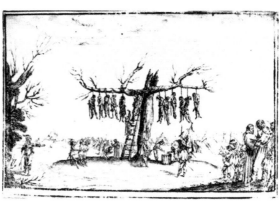

Six years on and for the first time in its history Usk Prison had become a place of execution. Justice came at a high cost. Gibbs protested his innocence to the end but to little avail. On the day of his execution, the wretched soul was heard sobbing bitterly as the cold dawn added a little grey light to the night skies. When the prison chaplain began the service for the dead and began solemnly pronouncing, 'I am the resurrection and the life' Gibbs muffled lament turned into a howl of despair. His tortured cries reverberated throughout the prison. Both inmates and warders sat silent and still in grim contemplation of the harrowing futility felt by a man who knows with absolute certainty that the end of all things is nigh.

By the time he reached the black painted scaffold, Gibbs's legs had betrayed him. He was carried onto the platform and placed upon the trap door. Trembling and sobbing with his arms tied tight behind his back, he was asked if he had any last words. He replied, 'God forgive my sins. He knows I am innocent and am happy. He knows I die innocent. Goodbye, my parents, goodbye all. May the Lord have mercy upon me.'

The Lord's eyes were elsewhere. However, the hangman William Marwood was firmly focused upon the task at hand. With polished practice, he quickly placed the hood over Gibb's head, tightened the noose around his neck, took a nimble step back, and routinely pulled the lever as Gibb fell and was left to dangle until dead.

Murder, whether committed by the individual or the state, is a gruesome affair. Gibbs was the first of seven hangings to take place at Usk between 1874 and 1922, and one in thousands that have taken place in the name of justice across the UK. Hangmen such as Henry Pierrepoint, John Ellis, William Marwood and

The hangman William Marwood.

James Billington, who all visited Usk, were seen by the general public as men of duty with a hard job to do. Although they were appointed by law to carry out the court's ultimate verdict, hangmen were regarded as a curious breed who answered a curious calling compared to all the other cogs in the justice system such as judges, lawyers, policemen, and prison warders.

As Oscar Wilde once wrote about the visit of hangman James Billington to Reading Gaol when the playwright and poet was in residence there, 'He did not pass in purple pomp, nor ride a moon-white steed, three yards of cord and a sliding board, are all the gallows need. So with rope of shame, the herald came to do the secret deed.'

It's worth noting that as a child Billington was obsessed with hanging. He could often be found carrying out executions on dolls and dummies. After a stint as a miner, a wrestler and a pub singer, Billington became a teetotaller and Sunday school teacher and dedicated himself to execution with a single-minded pursuit. In the course of his career, Billington hanged 147 people, one of whom was Thomas Edwards, who murdered Abergavenny's, Mary Connolly.

To get a measure of Billington's cold-blooded practicality and emotional detachment from the job at hand, when prisoner Joseph Laycock asked the man who was about to execute him if it would hurt, the hangman simply replied, 'No, thou will never feel it, for thou will be out of existence in two minutes.'

Old Oscar, who wrote about hangmen and their 'secret deed'.

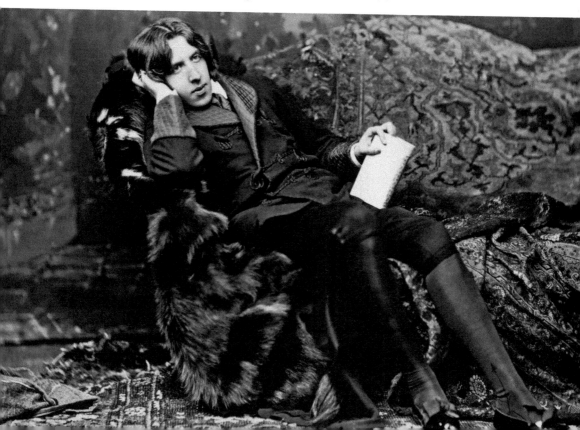

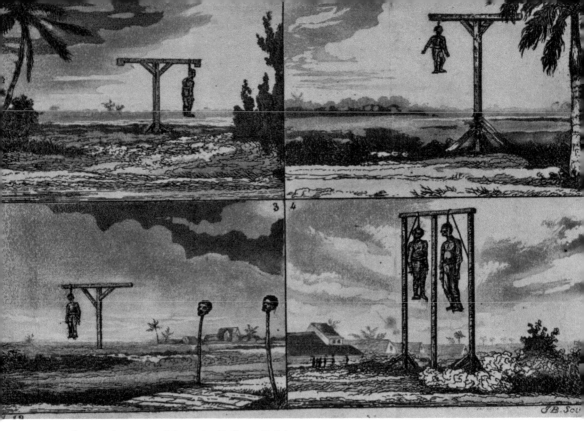

What can keep a soul from the Gallows Pole?

Three of Billington's sons would also follow in their father's footsteps after picking up the rope and heading to the gallows to hand out a bit of state-sponsored justice.

William Marwood, on the other hand, developed a morbid interest in hanging late in life. The former shoemaker hanged his first man at the age of fifty-four but also earned a reputation as a humane hangman for his invention of the long-drop technique. Prior to Marwood's Victorian innovation, the hanging rope was usually only 3 feet in length. This meant that slow and painful strangulation was normally the cause of death and not the more merciful and instantaneous snapping of the spinal cord. Marwood believed in execution and not torture. By lengthening the rope between 6 to 10 feet he believed the condemned would be saved the horror of dancing the Tyburn jig at the end of the rope as the life was slowly choked out of them.

However, not all of Marwood's executions went to plan. The killer Vincent Walker was said to have writhed in agony for nearly ten minutes as he passed from this world to the next.

Marwood visited Usk on two occasions. The first was to hang James Gibbs in 1874 and the second was to send Joseph Garcia to the cold of the grave in 1878. On the first occasion, Marwood demanded that a 3-foot pit beneath the gallows was dug out to accommodate the extra drop. Upon his second visit, he noticed the pit had become waterlogged and needed to be drained. In 1902 the

Charles Roll stands silhouetted in stone outside Monmouth Shire Hall, a venue where many were sentenced to the hangman's noose.

problem was solved indefinitely by erecting the gallows in the prison itself. The space chosen was directly opposite the condemned prisoner's cell. Whether by accident or design, the experience of watching the instrument of their own demise being assembled must have been a particularly poignant punishment.

Yet no matter how steely the resolve or steady the nerve, the taint and stain of cold-blooded butchery was bound to take its toll on the most hardened state-appointed hangman.

For twenty-three long years, John Ellis wore the cap of an official executioner. It was a role that never seemed to sit well with him. Riddled with anxiety and stress before, during, and after the hanging, the mild-mannered Rochdale barber who executed such notorious criminals as Dr Hawley Crippen regarded the executioner's role as a sacred duty that needed to be carried out as efficiently and painlessly as possible.

Lacking the level-headed practicality of the likes of William Billington, who described his colleague as 'always nervous and worried', Ellis was particularly against the hanging of women. Yet when the time came for him to do his duty and escort a semi-conscious and distraught Edith Thompson to the gallows, he didn't falter. Thompson hadn't actually murdered her husband but had been found guilty of aiding and abetting her lover who carried out the dark deed. Her execution haunted Ellis and may have been partially responsible for his resignation from his post not long after hanging a second woman, Susan Newell, at Glasgow in 1923.

A year previously Ellis paid his first visit to Usk to execute the killer of Margaret Thomas, William Sullivan, who was the last person to be hanged at Usk.

The notorious Dr Hawley Crippen.

A lifetime spent in the shadow of death caught up with Ellis. After tightening the noose around 134 killers, he began to drown himself in alcohol and turned the tools of his trade upon himself. His first attempt upon his own life was unsuccessful and a local magistrate gave him a firm reprimand to pull himself together. Unfortunately, Ellis was bent too far out of shape for that. On 20 September 1932, he carefully took a razor, and with his trademark neatness slit his own throat from end to end as both the life and despair bled out of him. Ellis had been executed by a hand whose unnatural familiarity with, and close and prolonged proximity to death had ultimately proved its undoing.

On one occasion at Chelmsford Prison, Ellis was once assistant to a man whose name looms large in the domain of public executions – Henry Albert Pierrepoint. Known simply as Harry to his friends and family, Pierrepoint once wrote, 'I love my work on the scaffold'. He was also riddled with jealousy that Ellis would knock him off the top spot as number one hangman. He snarled, 'If I ever meet Ellis I'll kill him – it doesn't matter if it's in the church!'

When Ellis and Pierrepoint finally came face to face on 18 July 1910, the afternoon before they were due to hang Frederick Foreman, the callous killer of his girlfriend Elizabeth Ely, it didn't end well. Pierrepoint, who had hanged Willian Butler at Usk four months previously, was in his cups. It didn't sit well with Ellis that an executioner of the state should hold themselves in such a drunken and undignified manner and he told him in no uncertain terms to behave and conduct himself with the standing and gravitas which his role warranted.

Such a reprimand from a man he regarded as his junior was like red rag to a bull for Pierrepoint, who launched a volley of verbalistic vitriol in Ellis's face. He then physically attacked Ellis with a flurry of blows and the raging and roaring

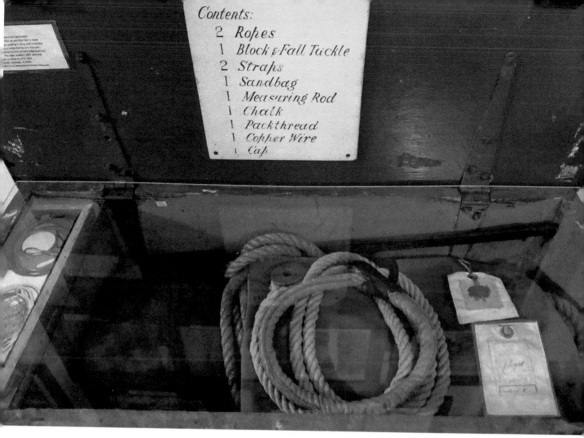

Contents:
2 Ropes
1 Block & Fall Tackle
2 Straps
1 Sandbag
1 Measuring Rod
1 Chalk
1 Packthread
1 Copper Wire
1 Cap

The tools of the executioner's trade.

hangman's assault only ceased when he was dragged off his fellow executioner by the prison staff.

On the morning of the execution, the two men were professionalism incarnate. The hanging was as polished and perfected as any they had conducted. Unfortunately for Pierrepoint, the authorities had got wind of his conduct and he was shortly told his services were no longer required by the state. Ultimately Ellis did prove his undoing but not in the way Pierrepoint envisaged.

Pierrepoint's legacy lived on his son whose fame made him a household name. Between 1932-1956, Albert Pierrepoint earned a reputation as the most prolific and proficient executioner of modern times. He sent over 200 Nazi war criminals into the abyss at Nuremberg and served as the cold hand of justice in the hangings of some of Britain's most notorious killers.

Yet after twenty-four years and over 450 hangings, Pierrepoint wrote in 1974, 'Hanging is said to be a deterrent. I cannot agree. There have been murders since the beginning of time, and we shall go on looking for deterrents until the end of time. I have come to the conclusion that executions achieve nothing.'

Pierrepoint's words were held up as sound validation by supporters of the Abolition of Capital Punishment law. which was passed in 1965. The argument that public execution is an unforgiving full stop that doesn't entertain the possibility of a second chance or an individual's reformation has long haunted

those who believe that everyone is worth more than their most evil act and all human life deserves a shot at redemption. There is also evidence that suggests that hanging was always a poor deterrent to murder most foul and cheapened the sanctity of life in the eyes of society as a whole.

Yet there is another argument that stresses that acting as a deterrent was never the purpose of hanging. Its sole function was to permanently remove from society and cleanse the world of those who would butcher and slay and make the world a poorer place with their murderous whims.

Can a person who steals another's future ever claim the right to one of their own in good conscience? And in the five decades since hanging was abolished as being inhumane and unjust are we living in a society where human life is regarded as more sacred and given more protection by the full force of the law?

The old adage rings true; if we keep taking an eye for an eye everyone would soon be blind, but by the same token, we cannot turn a blind eye to the anguish of the victims whose lives ended in terror, and the grief of the loved ones they were so cruelly snatched from. Are some crimes so horrific that perhaps only a justice as old as the hills would best serve their perpetrators?

It is an answer for every individual to decide. In 1976, two years after declaring judicial executions as achieving nothing Albert Pierrepoint changed his opinion. The face of modern crime appalled the former hangman. He retracted his earlier comments and once again viewed the stark, steady and unshakeable silhouette of the gallows in a far more favourable and forgiving light.

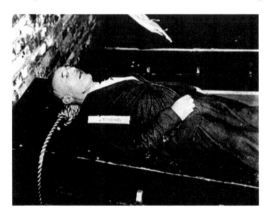

Julius Streicher was one of the many Nazis sentenced to hang at Nuremberg.

Norblin's hanging of traitors in effigy.

7. A FAMILY AFFAIR: THE CURIOUS CASE OF PRIMROSE WHISTANCE

It was a fine Friday morning in June. The birds were singing, the sky was blue and the warm southern breeze carried a promise of a better future for the world and everyone in it. A world which was slowly recovering from the carnage and suffering of the First World War, which had ended but two years previously. Yet in a picturesque cottage in Llanvetherine there lay a sight that would not have been dissimilar to those which haunted the ravaged souls who returned from the killing fields of France. For in that nondescript abode lay the battered and brutalized body of fifty-three-year-old Sarah Anne White. The poor woman's blood was splattered all over the floors and walls of the bedroom where she lay, and her skull had been shattered from repeated blows to the head.

The trenches of the Somme, where bloodshed and carnage was commonplace.

Police Sergeant Hatherall was the first official on the scene. The officer would later describe the sight that greeted him as 'sickening' as he grimly noted the bits of skull and brain on the floor.

It was thought that Mrs White had been attacked in the early hours of the morning. Judging from the disarray of the room there appeared to have been a violent struggle before she was stunned into submission. By the side of Mrs White's bed there lay what was thought to have been the murder weapon – a mallet.

The mallet, which was of the type used for driving in stakes, was covered in blood and hair.

When Sergeant Hatherall's superior officers visited the crime scene they thought it was advisable to call in the assistance of Scotland Yard. A telephone call was made to London and Chief Inspector Helden and Sergeant Soden arrived at Llavetherine early on Saturday morning.

Mrs White's body was initially discovered by her fifteen-year-old niece, Primrose Katherine Alice Whistance. Primrose was known to everyone as Katie and had lived with her aunt at Rose Cottage for four and a half years.

Apart from the companionship of her niece, Mrs White had lived alone since the death of her husband sixteen years previously. She was well respected and liked by everyone in the village as a reserved but kindly soul. She was said to have always dressed smartly and was always very particular about her attire.

During her interview with the police, Katie, who the *Chronicle* described as 'an attractive and intelligent-looking girl', explained she had been living with her aunt for four years though she helped during the day at Trerhiw Farm, the residence of her uncle a few 100 yards away.

A picture of Primrose.

Katie explained that during the day of the murder:

Auntie seemed very strange and gave me a ring as a keepsake. I went for a cycle ride in the afternoon and when I came back she said - pointing to a box which she had put my best clothes 'You had better take that up to your mother tomorrow morning as I cannot keep you any longer.' I did not say anything and went to bed at 9.30 pm. I always slept with auntie but on Thursday she did not seem if she could sleep. She kept twisting and turning and I could not go to sleep.

At last when it was after midnight I asked her if she had been to sleep and she replied, 'Never you mind. Go to sleep yourself!' She still kept twisting and turning and I could not get to sleep. At 3.30 am when it was still dark she said to me 'You had better get up now and be off before many people are about.'

I dressed and went downstairs but before I left the bedroom auntie said to me, 'leave the front door unlocked and don't be more than an hour and a half. I am expecting someone. If there is anything wrong when you get back go for the sergeant at once. I am going to get up now.'

Katie informed the police she had no idea of the identity of the guest her aunty was expecting but left the house at around 5 a.m., leaving the front door unlocked.

When she returned later that morning Katie said at first glance everything appeared normal except she 'could not find auntie anywhere'.

The holding cell at Monmouth Shire Hall.

Katie explained, 'I called out "Auntie! Auntie!" and then as there was no reply and everything seemed so quiet I went for the sergeant. He came back with me and told me to stay outside while he went upstairs. He came down almost immediately and told me that auntie had been murdered.'

The following Monday, officers from Scotland Yard arrested Katie at her mother's home at approximately 8.30 p.m. and charged her with the murder of her aunt. The very next day the young girl was brought before the magistrates.

The *Chronicle* reported: 'The mother of the accused arrived carrying in her arm an infant baby while her little son aged six trotted by her side. Their dress and appearance bore the stamp of penury and they were a pathetic trio.'

Considering the crime with which she was charged Katie was remarkably self-composed. A newspaper report states,

As one gazed at this attractive and intelligent-looking girl of refined and gentle appearance attired in a smart fawn dress one felt amazed that she was regarded as the central figure in such a brutal crime. She cast her eyes on the ground and continually fidgeted nervously with her hands and occasionally bit her lip, as though to repress her feelings but otherwise she did not show any outward sign of emotion until Inspector Helden of New Scotland Yard gave his statement and she broke down in tears.

The steps Primrose would have walked from her cell to the courtroom.

Chief Inspector Helden told the court he arrested the prisoner at her mother's home on Saturday 12 June for the murder of her aunt. Upon her arrest, Kate said, 'I did not do it. What makes you think I did?' She was later taken to the police station and made a statement that Inspector Helden said he would present as evidence to the court at a later date.

The prisoner was remanded until 28 June.

The next day was the funeral of Mrs White. Katie's mother explained that before her arrest her daughter was talking about going to the funeral.

'I said "One of us must go" and she replied, "I should like to go". I said to Katie the other day, "Who is going to look after the graves now that your auntie has gone?" And she said, "I will do that if no one else will, as I always helped auntie to do it."'

The Chief Constable told the *Chronicle* that no further arrests were likely and the full story would be disclosed at the adjourned inquest in June. During this period Katie maintained her innocence and repeatedly claimed, 'I did not do it'.

During her next court appearance, the *Chronicle* noted that Katie was 'Smartly dressed and wore a fawn macintosh and a blue straw hat trimmed with light brown ribbon. There were no tears in her eyes and she had not been the appearance of one who had been crying or who was on the point of bursting into tears. Indeed she was remarkably composed and self-possessed.'

The cells at Monmouth Shire Hall as they look today.

Katie's guilt appeared beyond doubt when the court finally heard the confession the accused had made to officers on the night of her arrest.

Chief Inspector Helden told the court that after Katie signed the confession she was given a glass of hot milk, which she drank, and after a few moments said, 'I feel better now. I have not had much sleep lately. I was going to tell my mother about it when it was all over.' She then said she felt tired and fell into a deep sleep.

Katie's statement read,

> Now I am here I may as well tell you the truth about it. I did murder my auntie. On Thursday the 10th of June my aunt grumbled at me for being out late about a month ago and told me I should have to go. She then packed my box and told me I could take it in the morning. We had supper together and went to bed about half-past nine. Auntie went to sleep and I also went to sleep. I woke up sometime in the night. I went downstairs to the back kitchen and got the mallet. Auntie had told me to bring it in on Thursday evening from the stable. I went upstairs and hit auntie with it and she fell out of bed. I hit her again on the floor. I then got my box and my bicycle and went to my mother's. I worried about my auntie turning me out and knew I would lose a good home.

Chief Inspector Helden added that shortly after he arrested Katie she fainted and when she came to she was crying for about twenty-five minutes before asking him, 'What can they do to me for this?' To which he replied, 'That is not for me to say.' It was for the jury of twelve men and women who would sit in judgment on Katie at the Monmouthshire Assizes in November.

Interestingly enough, on 9 July the police at Scotland Yard received an anonymous letter alongside a photograph of a young man who stated he, not Katie, murdered Sarah Ann White.

The letter was simply signed 'Cox' and it was posted on 8 July from somewhere in South London.

The back of the photograph was stamped 'Up to Date Studios 189 Southwark Park'. Police contacted the studio and discovered the man in the photo had visited the studio three weeks previously and given the name Mr Smith and an address in Bermondsey.

The address was a Salvation Army house, and they confirmed that the man in the photo was a labourer called James Fox, who had lived at the home from 21 April to 21 June 1920.

A check of the records confirmed that Fox had been registered as sleeping on the premises during the dates of the murder. Fox denied writing the 'confession' letter and a sample of his handwriting did not match with the hand that had penned the letter.

Fox admitted the photograph was of himself but said it was one of many he purchased from 'Up To Date' studios, and which he generously distributed

The foreboding walls of Cardiff Prison.

amongst chosen lady friends at the Salvation Army Hotel. Police decided not to pursue this line of inquiry any further.

On the day of her trial, Katie travelled from Cardiff Jail to Monmouth's Shire Hall. A large crowd gathered to catch a glimpse of her and her appearance was noted as being, 'Even more robust than before she was committed. Her appearance bears ample testimony to the fact that she has been well looked after and the prison environment has not prejudicially affected her health.'

She appeared at the Monmouth Assizes before Mr Justice Lush and sat through the long nine-hour proceedings quite stoically without showing any emotion or seeming to realize the gravity of her situation.

The *Chronicle* reports:

Several times she dropped her eyelids and seemed in a half-doze. Twice she was highly amused at incidents in the proceedings. The first incident when her mother was in the witness box and giving evidence with a baby in her arms. Katie's smiling face was in mark contrast to her mother's phlegmatic countenance. And the second time she smiled was when the prosecuting counsel remarked that girls at the critical ages of 15 and 16 were sometimes unable to resist sudden impulses.

In their opening speech, Katie's defence made the remarkable plea that it would be better for the girl to be found guilty than guilty and insane because if the jury returned the latter verdict she would be detained in a criminal lunatic asylum.

Katie pleaded not guilty but the jury disagreed and after a retirement of twenty-five minutes the jury returned a verdict of 'guilty'. The foreman said he hoped the girl would be dealt with as leniently as possible on account of her tender age and the environment in which she had been brought up.

Addressing the prisoner, the Judge said,

> If the evidence was not clear as to lead to no other conclusion one would have wondered if it was possible for a girl of your years to have committed such a terrible crime against one who treated you with every kindness. I hope you have asked and will receive forgiveness. I have now this duty to perform. I record no sentence. I pass no sentence. I only order you to be detained during His Majesty's pleasure.

The accused was taken down to begin a new life governed by cold iron bars, unforgiving discipline, and the monotony of despair. And so ends what local folklore has come to regard as the tragic tale of the 'lonely cottage murder'.

The churchyard at sleepy Llanvetherine.

8. ROUGH JUSTICE:
THE PUNISHMENT EXCEEDS THE CRIME

In 1842 a house of correction opened its grim doors upon picturesque Usk. A little over twenty-six years later its imposing and guarded walls became known as the Monmouthshire County Gaol. Although home to hardened villains and career criminals, many of Usk's inmates were simply tragic figures who were down on their luck and struggling to survive in a world and time where being poor was seen as a punishable offence.

Pre-seventeenth century it is estimated that about 80 per cent of all crimes went unreported. The victims were apparently reluctant to report them for fear that the offender would be dealt with savagely or sentenced to death by an unforgiving and stony-faced court.

If unlucky enough to find themselves in the grim confines of Usk Gaol, prisoners had little else to occupy their time except for hard labour. When they weren't breaking rocks in the hot sun or futilely wasting their time untwisting rope, they were vacantly killing time on the treadmill or endlessly turning the arm of the crank machine and wondering where it all went wrong. Each prisoner was forced to complete a certain amount of revolutions per day and prison wardens would often tighten the screw to increase the resistance and make the convict's lie harder. Hence how 'screw' became the slang term for a prison warden.

Either way, you slice and dice it the futile, and forsaken existence of prison life was hardly rehabilitative and the punishment often far exceeded the crime.

A plaque for the prison.

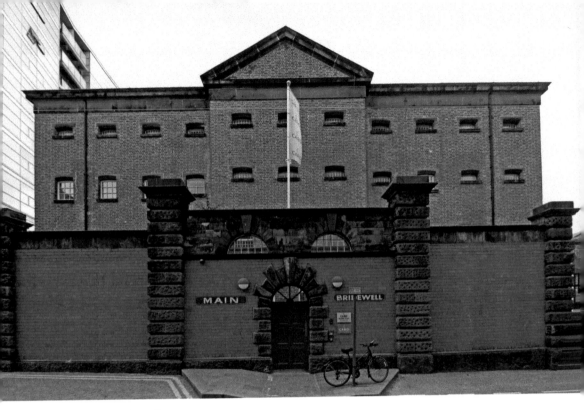

An original Bridewell!

For an idyllic rural retreat renowned for its flowers and fancy way of life, it is one of life's little quirks that the history of Usk is also the history of incarceration. For those who flock to Usk seeking an escape from the pressure and pain of modern life, it's worth remembering that this sleepy part of Monmouthshire has for centuries housed an institute of despair and deprivation.

Prisons or houses of correction were once known as Bridewells. The name stems from King Henry VIII's pleasure Palace of Bridewell. Once used to entertain foreign monarchs, by 1550 Bridewell had become a poor house which also doubled up as a makeshift gaol.

Menial tasks and punishment went hand in hand in Bridewell and as it was a handy place to keep all of society's undesirables under one roof, the trend soon caught on elsewhere in the UK.

A Bridewell type institution in Usk was first recorded in a 1630 Town Survey.

In Joseph Bradney's *A History of Monmouthshire*, he refers to philanthropist John Howard's 1770's report on the State of the Prisons to highlight the squalid and soul-destroying conditions that existed in facilities such as the one in Usk, where many inmates succumbed to starvation or gaol fever, which in fact was another term for a lethal dose of typhus.

Up until the early 1780s, prisoners were left to contemplate their confinement in the prolonged twilight of a bone-idle wretchedness. This all changed when some resourceful entrepreneur types realised there was money to be made in other people's misery and put the convicts to work for the good of the country.

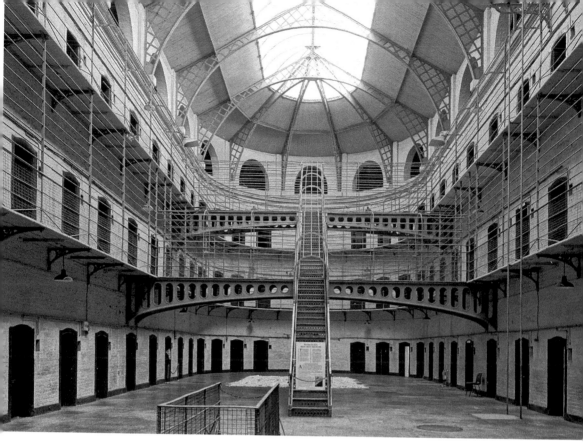

Above: A dark Satanic Mill.

Below: Pick prisoners, pick!

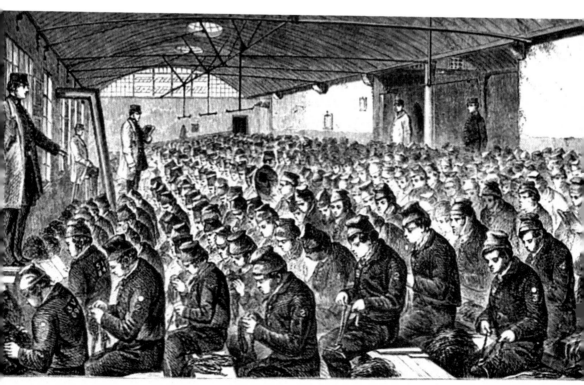

Smashing stones to smithereens and oakum picking was just a couple of the opportunities on offer for prisoners to better themselves. Oakum picking, in particular, was a vile and loathsome chore that could paralyze a prisoner's mind quicker than watching paint dry. It involved picking away at large disused ropes until individual fibre was picked clean and the picker's hand was red raw. The fibres would be cleaned and used for mattress filling or mixed with tar and used as a material to waterproof boats.

Gwent Records Office still has a copy of Usk's House of Correction keeper's book for 1821–34. It is a revealing read and shows you didn't have to be particularly bad to end up in that dark satanic mill, just unlucky. For example, one poor unfortunate from Llanfoist called Mary Howard was sentenced to hard labour for a year for the crime of giving birth to a child outside of wedlock.

Vandals were also given short shrift. William Morgan was banged up for a month simply because he vented his 'unlawful and malicious' rage upon 'one chestnut tree and one gooseberry tree in a certain garden'. Being idle and disorderly could land you in hot water too. Llangibby's Richard Powell also spent a month under lock and key for not providing for his family.

And just imagine the indignity of being given three months for stealing three cabbages? That's a month per vegetable. James Williams was left to stew on that whilst going stir crazy in 1827.

Even a spot of angling could lead to uncharted waters. In 1822 William Matthews was carted away for a two-month stint after 'having used a hook for the destruction of salmon in the River Usk'.

Times were hard and hard times were even harder, but it was about to get worse in Monmouthshire with the building of a new goal, which was run according to a sadistically enforced regime of complete silence and separation known as the Pentonville Model.

The original Pentonville Prison was built in North London in 1842. Based on American penitentiaries in America, the Islington 'nick' soon became the gold standard for all other prisons in the UK, including the freshly built grey granite edifice in Usk.

Although life was grim in the old Bridewells, it was a bearable hell where you could converse and pass the time with your fellows whilst doing penance in the belly of the beast. On the other hand, the Pentonville system took a keep them quiet and keep them separated stance.

Prisoners were not allowed to speak or mingle with one another because it was believed that it would lead to a decline in their spiritual and moral well-being. Mingling with their muckers was also considered detrimental to their rehabilitation.

Solitary isolation in dark, dank, and vermin-infested cells was considered the way forward. Naturally, forcing humans not to do what they do best – namely communicate, converse, and cooperate – led to minds being lost, moral compasses

Before Usk there
was the Monmouth
County Gaol.

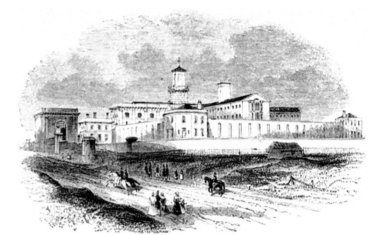

It was rough, tough
and wicked doing time
in Pentoville.

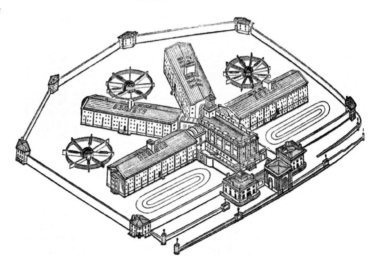

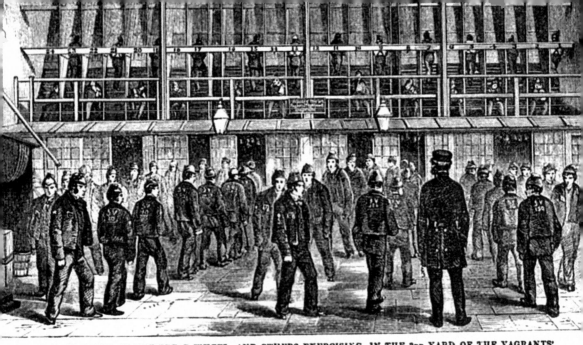

PRISONERS WORKING AT THE TREAD-WHEEL, AND OTHERS EXERCISING, IN THE 3RD YARD OF THE VAGRANTS'
PRISON, COLDBATH FIELDS.

(From a Photograph by Herbert Watkins, 179, Regent Street.)

The road to nowhere.

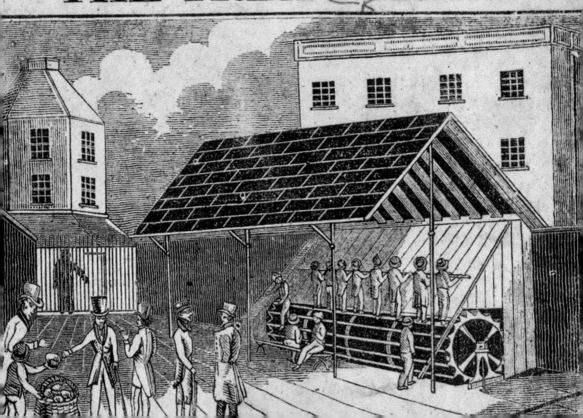

THE TREAD-MILL.

being broken, and a blanket erosion of a person's finer sensibilities. In other words, complete mental and moral deterioration held sway.

Even when spending their days plodding wearily on the soul-crippling and mind-paralyzing treadmill, prisoners were not allowed to talk to one another to relieve the tedium. All they had to look forward to at the end of another 'working day' was a bowl of gruel and some stale bread tossed into their cell, much like you would toss a dog a bone, before the door banged shut and the sunset on another cycle of misery and deprivation.

A former prisoner is reported as having this to say about the separate rule:

> Unless one has experienced it, once can have no conception of the effect of close confinement upon the nervous system. People who have not tried it are apt to say, 'Well, it's only for 28 days.' But if they were to try what it was like having nothing but white-washed walls to stare at day after day, and neither book nor employment to take one's thoughts, as it were, out of one's self, I don't think they would say anything more about it being 'only 28 days'.

For those few who tried to keep their heads up and buck the system, their daring disobedience was met with the stinging lash and harrowing humiliation of the cat-o'-nine-tails. When facing the discipline of the whip, even the most hardened convict would tend to scream in pain by the third lash and fall into moaning like a soul abandoned and forsaken by the seventh. Before the ninth lash came down most men were rendered still and silent, but the sweet relief of blessed unconsciousness was denied them as every time they passed out a bucket of ice water was thrown into their face so they could continue to feel every inch of their drawn-out degradation. Eventually, there was little skin left to flay, and the hand that carried out the flogging was stilled and given extra coin for services rendered.

As the beaten and broken prisoner was carried back to his cell, his fellow convicts would bow their heads and turn away, remembering the cries and screams that had filled these unforgiving corridors earlier.

Although most prisoners made it through their captivity to liberation, their time behind bars had a lasting effect. Yet freedom offered little relief when faced with the poverty, strife and lack of opportunities that life in the wider world usually entailed, and so a vicious circle of petty crime and incarceration would play out in ever-decreasing circles.

For the most part, the general public thought the prisoners got what the prisoners deserved; yet, as was the case with the Bridewells, these weren't hardened criminals who were being exposed to the sharp end of man's inhumanity to man. They were everyday people down on their luck.

Take the case of Joanna Betts. On 24 February 1871, the *Monmouthshire Merlin* reported that Joanna's two boys, William Clements Betts (fifteen) and James Betts (eleven) were charged with stealing a lump of coal from a railway wagon at Newport's Cork Wharf. The two lads were given a day behind bars to

FLOGGING POST—SHERWOOD—"THE MAN OF FLOGS" getting in some fancy work

Whipping up a storm.

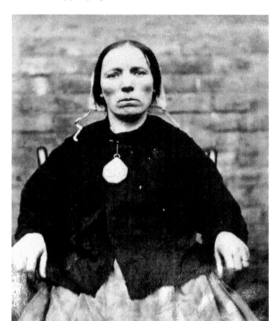
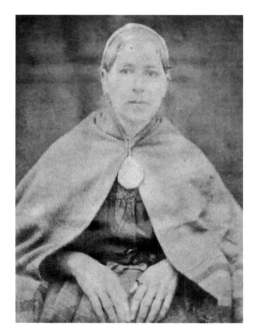

Joanna Betts and Jane White, who both fell foul of the law in Monmouthshire.

dwell on their mistakes and twelve strokes apiece with a birch rod. Here's where justice gets rough to non-existent. Johnna was sentenced to twelve months' hard labour simply because the boys were her responsibility. A few months after her release the thirty-five-year-old died after falling down the stairs.

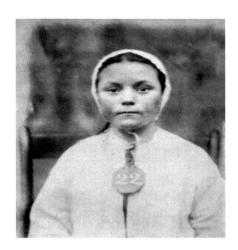

Sarah Hone, James Clifford and George
Brown. Mugshots from a period
when the full weight of the law was
extremely oppressive.

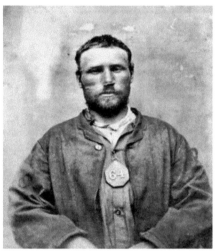

And then there's poor old Sarah Hone. As a twelve-year-old, Sarah got her first taste of hard labour at Usk Prison for the crime of stealing a scarf. A short while later she was sentenced to five years at reformatory school for sleeping in someone's outside toilet merely to escape her drunk parents' mistreatment of her. Her 'rehabilitation' led to her dying in a Monmouthshire workhouse in 1899.

The list goes on. Jane Ann White was given three months' hard labour for stealing some rashers of bacon. Randolph Pearcey got six months for stealing six

The world goes to war for the first time.

pieces of wood. Gardener George Pegler stole a pair of brass candlesticks and was handed three years for his brass-necked cheek. Sailor Olaf Hansen stole a mouth organ and was given a sentence to the tune of seven days. Ragman Will Wiltshire blew a horn in the street and was silenced for seven days for disturbing the peace, and barman Sam Winkworth found himself on the wrong end of a three-year stint after forging a postal order.

Usk's most famous prisoner was the Viscountess Rhondda Margaret Haig Thomas, who would later marry Sir Humphrey Mackworth and become Lady Mackworth. This woman of gentle breeding found herself in the brutal confines of Usk Prison after becoming involved with Emiline Pankhurst and the suffragette movement. On 15 July 1913, she was found guilty of placing a bomb in a letterbox at Newport. As a wealthy woman, she was given the choice denied to most of the convicted – pay a fine or be banged up for a month. Being a high-minded sort, Lady Mackworth stuck to her guns and chose imprisonment. After six days of refusing food and coming face to face with the stark reality of prison life, her wretched predicament proved too much for her husband Sir Humphrey, who forked out for the fine of £20 and got her released.

In 1858 a report stated that Usk Prison housed a total of 770 prisoners, 559 males, 211 females, and six children under twelve years of age. 230 of the prisoners were said to be completely illiterate.

The Widow of Windsor. Millions were imprisoned for her 'Majesty's pleasure'.

However, the winds of change had begun to blow softly across the land as some influential and social figures demanded that a change should and was going to come.

In April 1878 the Prison Visiting Committees group was established upon the orders of the Secretary of State. The group would report on prison conditions and the treatment of prisoners. Slow and steady things began to take a turn for the better with this benign group at the helm.

The First World War changed everything and prison life was no exception. With all able-bodied men sent to France to die as the generals saw fit, crime levels dropped as did the prison population.

Usk Prison survived the war but the writing was on the wall, In 1918 thirty-year-old prostitute Mabel Dale became the last female to be imprisoned at Usk, and also in that year Sinn Fein activist Richard Coleman was denied ever seeing his beloved Emerald Isle again when he passed away within the prison walls on 9 December.

Four years later Usk Prison closed its doors for good. Upon the outbreak of the Second World War, it reopened as a closed borstal and would later become a youth custody centre.

Since 1990 it has been an Adult Category C prison, housing inmates convicted of sexual offences.

Although both times and regimes have changed, this Victorian gaol continues to cast a brooding shadow over Usk and stands to remind all of how crime and punishment have and continue to shape society.

9. WICKED JEREMIAH: THE GREEN-EYED MONSTER

The high and lonely town of Tredegar was the birthplace of the architect of the NHS, Aneurin Bevan. Yet some five decades before the son of a miner transformed Britain with his radical idea of free healthcare for all, a savage murder left the town and its community reeling.

Like many of his countrymen during the Industrial Revolution, Irishman Jeremiah Callaghan arrived in the Welsh Valleys looking for work at the coalface, the ironworks or the quarry.

Jeremiah had a reputation as a brooding individual who was hard to handle and something of a ne'er-do-well. He had served in the army for a number of years and was known by the locals as 'Jerry Canteen'. Yet Jeremiah was neither disciplined nor governed by a strong work ethic. He was a work-shy soul who when not in his cups or looking for a scrap, was dodging steady employment like a bullet.

The NHS's architect meets a patient.

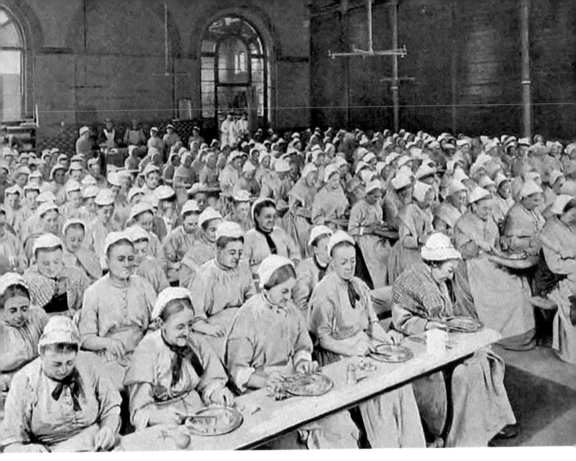

The grim life of the workhouse women.

Yet with a thirty-eight-year-old wife, Hannah Shea, and a son and three daughters residing in the Bedwellty Union workhouse, the pressure was on Jeremiah to find a job and stick at it.

Being a labourer for a firm of local stonemasons wasn't Jeremiah's dream gig but he decided to make a go of it, save a few quid and find some decent lodgings for himself and his family.

However, as he sweated, slaved, and saved, the green-eyed monster, which has been the ruin and rot of many a man, began to plague Jeremiah's thoughts. He began to grow increasingly paranoid that Hannah was taking what meagre earnings he had and blowing them on alcohol. He also began to cultivate a gnawing suspicion that she was sleeping with another fella.

Things came to a head on Saturday 4 October 1902. Alongside her children and other friends, she decided to leave the workhouse for a day and visit Tredegar. When Jeremiah got wind of this, he was keen to meet up with his kin, but things didn't go to plan. Hannah and the kids weren't at the designated meeting point – the railway station – and this served to fan the flames of the hot-headed Irishman's wrath.

With murder in his eyes and curses on his lips, Jeremiah took to the town like a vengeful god. He searched pub after pub looking for his wife and eventually

Tredegar town's iconic clock.

found her sitting outside the Miner's Inn with her children and a lady named Mrs Prothero. Jeremiah accused Hannah of being a slave to the bottle and wasting his hard-earned cash on booze. She flatly and fiercely denied this, which proved to be the last straw for her husband. With a snarl and a sneer, he punched her to the pavement.

Picking herself up off the floor, a bruised and indignant Hannah gathered her children and marched up Church Street, away from her husband and his uncontrollable rage. Yet Jeremiah was just warming up and followed hot on her heels. Fortunately for Hannah, a member of the local constabulary appeared on the scene and warned Jeremiah to back off. Not foolish, angry, or intoxicated enough to get into a beef with a strapping and no-nonsense policeman, the Irishman did as he was told and disappeared from sight. As for Hannah, she and her children returned to the Miner's Inn. Later that afternoon Hannah and her children would accidentally bump into a now deeply contrite Jeremiah in the town's Circle where the iconic clock overlooks all and sundry. Jeremiah apologised for letting the old familiar rage seize him in his grip and offered to buy Hannah a few rounds of drinks at The Black Prince as a way of apology.

Basking in the rosy glow of alcoholic numbness, Jeremiah and Hannah stumbled out of the pub in the fading light of a sunny autumn afternoon with their children in tow. Jeremiah, who at this point was said to be falling down drunk, had decided to escort his family back to the workhouse. Along the way, they met Hannah's workhouse friend, Jane Hannam, and the two women fell into chatting idly about nothing in particular.

As they gaily conversed and waltzed along the hillside an observant bystander would have noticed that Jeremiah had fallen into a heavy silence, oppressive and menacing in nature. It was a loaded and ominous quiet, which should have forewarned vigilant watchers of the storm and outburst to come. Yet Hannah and Jane were neither vigilant nor watchful on that fateful afternoon as whatever demons had been let loose to dance in Jeremiah's soul and drink-addled brain began to have their wicked way.

Without warning, Jeremiah suddenly drew a knife from his pocket and screamed like a man possessed. With a terrible symmetry of movement, he thrust his wife against a nearby wall with one hand as the one with the blade was viciously drawn across the poor woman's throat. Hannah screamed in an agonising fashion but somehow managed to break free of her husband's grip, and with the very life spilling out of her she fled down the hill.

Hannah's young son, also named Jeremiah, began to scream and throw stones at his father. With a knife in hand and a disturbingly vacant expression, Jeremiah began to walk in the direction of his sobbing children. The approach of their murderous father and the disappearance of their wounded mother, who was still screaming in the distance, was too much for the youngsters to bear, and they took their terror and fled up the hill.

King Alcohol and his court have been the ruin of many a soul.

Murder most foul is as old as the hills. Pictured is Moses receiving the Ten Commandments.

Meanwhile, in the opposite direction, Hannah lay in a pool of her own blood. Her cries had alerted the workhouse's cleaner, Sarah Morris. Having rushed to her aid, Sarah cradled the dying women in her lap as the blood continued to ooze from the jagged hole in her throat. A collier named William Pritchard also arrived on the scene and attempted to prevent the precious blood from flowing out of Hannah by wrapping Sarah's apron tight around the near unconscious woman's neck. A district nurse named Amy Pearl and Dr Isaac Crawford arrived and also determinedly struggled to keep Hannah alive as they waited for an ambulance. Yet as her breathing became strained, and the space between each heartbeat grew longer, her will lost its focus and shape. Eventually the wife of Jeremiah Callaghan could struggle no more and the light behind her eyes slowly faded. She died at precisely 6.45 p.m. As death and the night darkened the hillside, the cleaner, the collier, and the nurse picked up the lifeless body of the woman they could not save and carried her with a gentle and careful grace back to the nearby workhouse.

An eyewitness who had passed Jeremiah leaning like a three-day drunk against a stone wall had reported him to the workhouse's master, William Thomas. The suspicious individual with heavily bloodstained sleeves, bloodshot eyes, and breath which stunk like a brewery had been brought to the workhouse for questioning, and was on the premises when the corpse of his wife was taken to the mortuary.

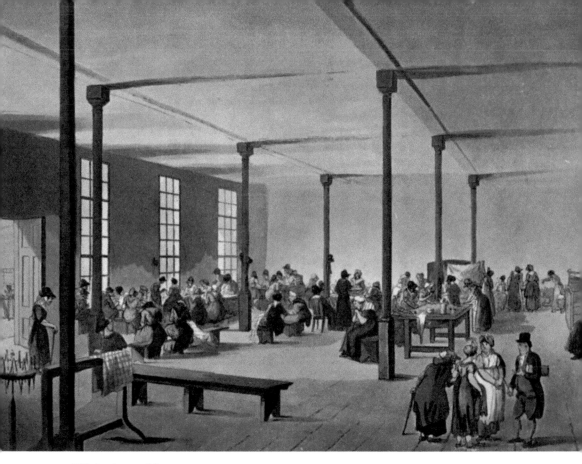

Life in the workhouse.

Thomas informed Jeremiah of his wife's death, to which he simply replied, 'Can I see my children?' The request was declined and as all present waited for the police to arrive, they were amazed to see the killer stumble out into the courtyard and jig and dance like a man intoxicated with all the joys of spring. He appeared far removed from a man who had murdered his wife, orphaned his children, and who had condemned his body to the gallows and his soul to the dark corners of hell.

The police arrived to question Jeremiah but they could not make any sense out of his incoherent ramblings or depraved rantings. They took him, threw him in a cell, and gave him a day to sober up and come to his senses. When sobriety had returned, Jeremiah appeared completely dumbfounded when told of his wife's death. He asked once again to see his children, who were residing back at the workhouse, but was once again denied.

On 7 October 1902, under the watchful eye of James Berry Walford, an inquest was held and a jury didn't hesitate to find Jeremiah guilty of wilful murder. He was committed for trial at the Monmouth assizes on 22 November 1902. The court heard how an engine driver called Mr John Williams had spotted Jeremiah on the hillside attempting to use little scraps of paper to wipe his wife's blood off his hands. When Mr Justice Forbes called William Pritchard to the witness box

Jesus might have forgiven Jeremiah; the law of
the land could not.

he testified that he had seen Jeremiah, Hannah, and the four children on the day
of the murder in Tredegar town, and Jeremiah was so drunk he was constantly
falling into the gutter and could not seemingly walk without the aid of his wife.

Dr Crawford, who was present when Hannah died, also performed her
post-mortem and stated that the attack on her person was so savage that both
her jugular and two other arteries had been slashed. He also commented on a
particularly nasty injury to the head, which was believed to have been where her
husband had struck her earlier that day.

The final witness called by crown prosecutor Mr J. R. V. Marchant was
Superintendent Francis Allen. The detective was the first policeman to arrive
at the workhouse and recalled how his first impression of Jeremiah was a man
puffing on his pipe without a care in the world. Allan said he took a nonchalant
Jeremiah by the arm and led him to a quiet place before charging him with
murder. He stated that Jeremiah could only converse in slurred tones, and upon
his person he found a knife that was still wet with the blood of his butchered
spouse. A further search of Jeremiah's clothing revealed an empty bottle of Irish
whiskey and a few shillings. Allen also noticed with a growing disquiet the specks
of blood on the backs of Jeremiah's hands.

In defence, Mr H. Hardy was left floundering in the face of such overwhelming
and substantial evidence, and so he decided the best ploy for his client was to cop
an insanity plea. He led with the argument that Jeremiah's act of violence was
caused by an attack of delirium tremens and suggested it was nothing more than
a momentary outburst of insanity. He argued in his closing speech, 'If delirium
tremens caused a degree of madness, even if only temporary, it relieved a prisoner
from criminal responsibility.'

THE TOWN HALL & PRINCIPAL STREET IN MONMOUTH,
from the Crown & Thistle Inn.

Monmouth's Shire Hall in times gone by.

Usk prison surgeon Dr D. Boulton had already carried out a thorough examination of Jeremiah and it was his professional and considered opinion that mentally the accused was as fit as a fiddle. Watching a seemingly unrepentant Jeremiah chat, act and conduct himself in the courtroom as if he was on some sort of jolly, the jury agreed, and within thirty-five minutes they returned a guilty verdict.

Mr Justice Forbes gravely placed the black gap upon his head and ordered that justice on this occasion would only be satisfied if an eye was taken for an eye. After delivering the death sentence the grave-faced judge solemnly told Jeremiah, 'I don't wish by any words of mine to aggravate the painful situation in which you stand, but from the circumstances under which you committed murder, I can hold out to you no hope of reprieve.' The execution date was set for Friday 12 December 1902, and Jeremiah was taken down to await his date with the hangman.

Father and son team William and John Billington arrived at Usk Prison to do the dark deed. The night before Jerimiah's sleep had been broken and plagued by a nightmare of what had been and was to come. The morning of his death was as bleak and desolate as any to be found in the grimmest midwinter. Jeremiah accepted his punishment and walked to the scaffold without a struggle. Before

Christ's Last Supper before his own execution.

the rope silenced him for eternity, Jeremiah cried out, 'Holy mother pray for me! Jesu help me!' As death as in life, the welfare and forgiveness of his wife and children did not appear to concern him.

10. THE DEATH OF A GENTLEMAN: A MURDER MYSTERY

The evil that men do lives on and on, and the act of murder is a stain on the pages of history. Although it can be covered up, whitewashed, absorbed, forgiven, or forgotten, it will never run clean. Its terrible taint is there to remind us that every murder victim demands a reckoning which the laws of man cannot account for.

When a person takes another life, they are murdering a past, present and future. Murder diminishes us all, but it diminishes the broken and damaged individual whose hand commits the deed the most.

The need for justice is strong in the human heart and although it cannot compensate or heal the wounds of those left behind, or bring those who are murdered back from the cold quiet of the grave, it can restore a little balance and a measure of faith in the order of things.

Which is why the spectre of the killer who steps out of the shadows to perpetuate their outrages, and whose identity and motive are cloaked indefinitely in a veil of anonymity, is infinitely more unsettling and unnerving to our sensibilities. If Jack the Ripper had been caught, it is extremely plausible that the identity of the man behind the cloak and butchery would have faded into obscurity before the last gaslight had gone out on the Victorian era.

The bloodied remains of poor Mary Jane Kelly, thought to be Jack the Ripper's last victim.

'Bloody Jack', the killer who escaped justice.

Yet over a century later, Jack's knife and wickedness stalk our imaginations in much the same way the man behind the myth stalked the fog-shrouded streets of Whitechapel.

Unsolved murders haunt us with the melancholy of those whose eternal rest is troubled. These voiceless victims have had grievous wrongs done to them that have never been righted. Unsolved murders also serve to taunt us with the gleeful mockery of those who killed without remorse or punishment. When those

Manical,
murderous and in
charge of a country.

who seek to play God remain free of man's justice, it throws the scales of justice off-kilter and strikes a chord of discord crying out for its natural resolution. Such is the case of William Alfred Lewis.

On the morning of 24 May 24 1939, the world, and in particular the UK, was preparing itself for a conflict promised by the dark storm clouds gathering over Hitler's Germany. Like many in the town of Pontypool, where he was a wealthy but popular and well-known figure, William was collecting his gas mask on that fine spring day which would prove to be his last.

The gas masks were being distributed from George Street School, and during his fitting, William had difficulty with the uncomfortable contraption, and was heard to mutter, 'I hope I shall never have to wear this thing.' Little did he know some savage hand would grant his throwaway wish that very night.

After leaving the school and walking the short distance to his seventeen-room, ramshackle Plasmont House home at 8.15 p.m., William closed the door on the day, the world and, as it would transpire, his very existence. The man who owned some 200 homes and shops within the town was never seen again.

The alarm bell was first raised the next morning when William, a notoriously early riser, had failed to make an appearance long after dawn had wrested control of the skies from midnight's grip. When the milkman arrived at William's residence, he found the door hanging ajar and yesterday's milk curdling on the kitchen table. Unsettled that one of his most chatty customers was nowhere to be seen, the milkman visited Mrs Barnett in the cottage next door and gave voice to his concerns.

Agreeing it was curious, Mrs Barnett decided to investigate. Fearing for her safety, the neighbour asked local builder Tom Brimble, who was digging ditches

VIEW NEAR PONT Y POOL.

A view of Pontypool before heavy industry ravaged the valley.

nearby, if he would enter the house with her. Brimble agreed, and so the unlikely pair ventured forth into the house of horror.

Both Barnett and Brimble's initial calls enquiring after the welfare of Willam were met with a deathly silence. Fearing the worst Mrs Barnett refused to venture any further into the house's hushed stillness. Brimble on the other hand was caught in the vice-like grip of curiosity and roamed ahead – his tread one of dread as the adrenaline coursed through his veins. The terrible tension and waiting quiet which appeared to flow through the very fabric of the house was eventually broken by a lone voice crying, 'Oh dear God no!'

Poor William's battered and bloodied body had been found. His lifeless body lay sprawled at unnatural angles on the bed, which lay in the middle of his ransacked bedroom. The man often described as 'shy and nice' had been beaten to death. His head had been caved in with a blunt instrument and a pillow had been placed over it. Whether this was an act of suffocation or because the killer couldn't bear to look at what his butchery had inflicted upon a fellow human being was for the police to decide. A shell-shocked and clearly distraught Brimble had already fled the macabre scene and the boys in blue were on their way.

Upon arrival, the local plod decided this was a job for Scotland Yard and hence the big wigs from the big smoke were called in. Led by the formidable Detective Chief Inspector Rees, the investigation turned the usually quiet Plasmont House into a hive of activity.

A job for the boys from the yard.

Due to William's great wealth, it was initially assumed that money was the motive behind this particular murder. However, a thorough inspection of the house revealed that mere inches from the body was a tin box containing a princely sum of £100 in sovereigns. Why did the killer discard such a substantial amount?

Nevertheless, the two safes in the house were both open and although they contained property deeds and other documents, there was no cash or other valuable items within. Alongside the house keys, the safe keys were also missing from the premises, as was the murder weapon.

A new way to pay the NATIONAL-DEBT, *Dedicated to Monsr. Necker*

Money! The root of all evil.

Somewhat embarrassingly for Chief Inspector Rees, the keys were later found in a briefcase that belonged to William and had been stored in one of his many rooms.

At the inquest on Thursday 25 May, it was ruled that William had been beaten to death whilst he slept. His injuries were consistent with those being inflicted by a shoe. The pathologist believed, in all likelihood, the assailant took off their own shoe to murder the victim. It was a strange murder weapon in a strange case that was never solved. Speculation in the town remained rife as to who exactly committed the crime. The extremely wealthy bachelor was rumoured to have been contemplating marriage and possessed a personal fortune of £50,000 when his days were cut prematurely short. His sister stressed there was a total of £300 missing from her brother's residence – the exact amount in rent money William had collected a few days prior to being murdered.

A message pleading for information about the murder was met with a wall of silence. The only tangible leads the police had were vague sightings of two young men hanging about suspiciously in the vicinity of Plasmont House the night before the killing. The lead led to a dead end and the hunt for the killer or

The police may have well been chasing shadows.

killers became something of an exhausting but nevertheless fruitless wild goose chase as they dug up the garden and re-searched the house. Police speculated that William may have met someone on the way home, or the killer was waiting in the shadows of his sprawling house, waiting to end the owner's days for whatever cold-hearted and callous reason.

Both local gossips and lawmen continued to chase rainbows and the only thing that everyone could agree upon was that William was in his grave and a killer walked free. It was a crying shame and a moral outrage but as the threat of war in Europe became a harrowing reality, people turned their attention to the promise of butchery on a far bigger scale.

When William was buried on Whit Monday 1939, the identity of his killer was buried with him. It has laid, festering and rotten, in the dark places beneath the soil for over eighty years. It looks unlikely that it will ever be unearthed.

William's earthly abode, Plasmont House, also went the way of rack and ruin and was later demolished. Its colourful history and the murderous act it bore witness too became little more than dust absorbed and absolved by a silent and watching earth upon which all our history is destined to be staged.

The secrets the dead take with them are many, as are the untold stories.

The future is uncertain but the end is always nigh.

Also available from Amberley Publishing

·SECRET·
ABERGAVENNY

TIM BUTTERS

Explore Abergavenny's secret history through a fascinating selection of
stories, facts and photographs.
978 1 4456 6688 4
Available to order direct 01453 847 800
www.amberley-books.com

Also available from Amberley Publishing

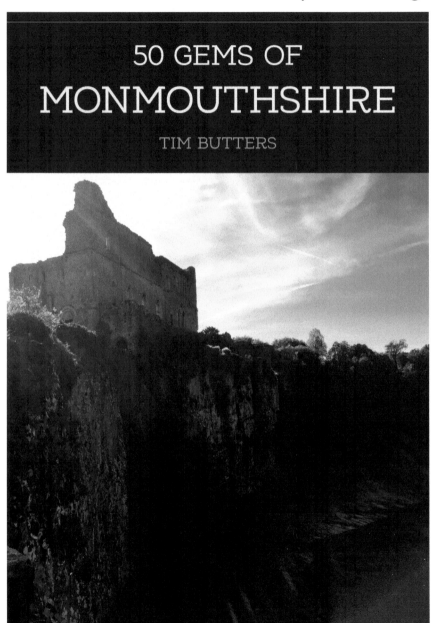

50 GEMS OF
MONMOUTHSHIRE
TIM BUTTERS

Discover fifty of Monmouthshire's special places that reflect the essence,
beauty and character of this south-eastern corner of Wales.

978 1 4456 9625 6

Available to order direct 01453 847 800

www.amberley-books.com